Sculpture by
Antoine-Louis Barye

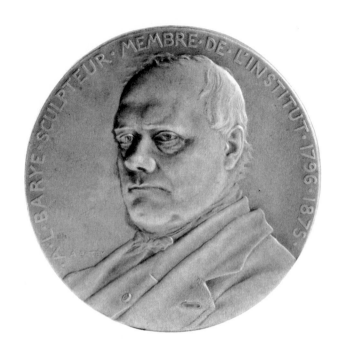

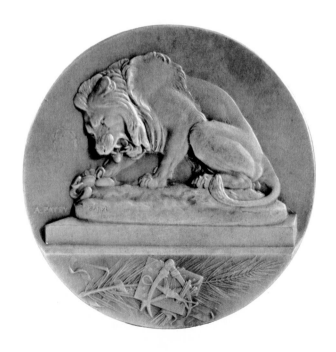

Medal by Henri August Jules Patey *(1959.1)*
obverse: Antoine Louis Barye
reverse: Barye's Lion Crushing a Serpent

Sculpture by Antoine-Louis Barye in the Collection of the Fogg Art Museum

Jeanne L. Wasserman

with technical assistance
by Arthur Beale

Fogg Art Museum Handbooks, Vol. IV
Fogg Art Museum, Harvard University
Cambridge, Massachusetts 1982

For Seymour Slive

On the cover:
Walking Tiger (no. 18, detail)

This handbook was produced by the Publications
Department, Fogg Art Museum:

Peter Walsh, Director of Publications

ISBN 0–916724–53–0

Contents

Foreword

This, the fourth volume in the Fogg's Handbook series, is the first to deal with sculpture. It is the work of the Fogg's Honorary Curator of 19th- and 20th-Century Sculpture, Jeanne L. Wasserman, whose commitment to our sculpture collections over many years has been an invaluable one. The Handbook is the result of Mrs. Wasserman's most recent exhibition, *A Bronze Menagerie and Other Works by Antoine-Louis Barye from the Fogg Museum Collection*, which was held at the Museum from September 25 – December 27, 1981. The Fogg's extensive Barye holdings had never been exhibited or studied as a collection, and Mrs. Wasserman soon learned that the bronze casts varied widely in quality and closeness to the artist's hand—from a plaster and wax model from Barye's studio, to several competent 19th-century serial production casts, to late surmoulages (casts of casts) in which the detail is blurred and the quality poor. In fact, the exhibition proved to be an excellent resource for the study of the complex problems of connoisseurship of 19th-century cast sculpture.

The didactic aspect of the exhibition prompted the Fogg's Director, Seymour Slive, to suggest to Mrs. Wasserman that she preserve the results of her research in a detailed study of the Fogg's Barye sculpture. In order to place the Fogg's casts among the various editions and castings in Barye's oeuvre, she thoroughly explored the Barye literature and, with the assistance of Arthur Beale, Director of the Center for Conservation and Technical Studies, compared the Fogg's casts with those of the same subject in three fine American Barye collections which were assembled during the artist's lifetime. The results of this research shed light not only on Barye's career (and that of his individual works as they passed from artist's studio, to artist's foundry, to casts and editions farther and farther from Barye himself) but also on the entire question of "originality" in bronze sculpture of the 19th century.

John Rosenfield
Acting Director
Fogg Art Museum

Acknowledgments

The realization of this catalogue depended largely on the availability for comparative study of the Barye sculpture collections in several American museums. We are especially grateful to the staffs of the Walters Art Gallery, Baltimore, the Corcoran Gallery of Art, Washington, D.C. and the Brooklyn Museum for their interest and help. Thanks are due in particular to Leopoldine Arz, Registrar, and Jennie Baumann, Assistant Registrar of the Walters Art Gallery; Judith Riley, Registrar, and Elizabeth Turpit, Assistant Registrar, of the Corcoran Gallery of Art; Annette Blaugrund, Assistant Curator of Paintings and Sculpture and Kenneth Moser of the Conservation Department of the Brooklyn Museum.

For valuable information and photographs we are indebted to Marielle Latour, Director of the Fine Arts Museums, Marseilles, France; Claire Vincent, Associate Curator of European Sculpture and Decorative Arts, Metropolitan Museum, New York; Martha S. Stout and Cynthia Draney, Assistant Registrars, the Nelson Gallery-Atkins Museum, Kansas City, Missouri; Gloria M. Ravitch, Assistant Curator, Department of Decorative Arts and Sculpture and Elisabeth Cornu, Associate Conservator of Decorative Arts, Fine Arts Museums of San Francisco.

We deeply appreciate the interest and help of Robert Kashey of the Shepherd Gallery Associates, New York, who came to Cambridge to view our Barye Collection and generously gave us the benefit of his knowledge and expertise. We are also grateful to Arthur Eli Huggins of New York who gave us permission to publish his photograph of a sculpture by Alfred Barye.

Two extraordinarily knowledgable collectors of Barye sculpture gave unstintingly of their time and experience and shared documents with us. Special thanks are due to Joseph G. Reinis of Brooklyn, New York, and Stuart Pivar of New York City, who traveled to the Fogg to see our Barye sculpture and whose comments added to our insights. In addition, we are greatly indebted to Mr. Pivar's 1974 book on Barye sculpture, which is rich in photographs and proved invaluable in the location of casts for comparison.

Important contributions to the catalogue were made by Jeremy Strick, a doctoral candidate in the Fine Arts at Harvard University, who assisted in assembling the Selected Bibliography and wrote the section on the Fogg's Barye prints; and Jill Beaulieu, who compiled the bibliographies for each entry and gave immeasurable assistance in the preparation of the catalogue.

We thank Agnes Mongan for her generosity in allowing us to include the checklist of the Fogg's Barye drawings excerpted from the manuscript of her forthcoming French drawing catalogue. Members of the Fogg Staff to whom we are especially indebted include Suzannah Fabing, Deputy Director, Phoebe Peebles, Archivist, Miriam Stewart, Curatorial Assistant, Anna Coyle, Financial Assistant, John Dennis, Assistant Conservator, and Martha Heintz and Michael Nedzweski of the Photographic Services Department. We are also indebted to Peter Walsh for editing the catalogue and seeing it through publication.

Finally, this catalogue could never have been undertaken without the enthusiasm and encouragement of Seymour Slive, Director of the Fogg, who saw in this uneven sculpture collection an unusual and useful instrument for teaching.

J.L.W. and A.B.

Note to the Catalogue

Most of the Fogg's sculptures lack provenance and foundry marks. In order to place them in the context of Barye's oeuvre, we compared our casts with similar sculptures in three American collections formed during Barye's lifetime, which include pieces bought directly from his ateliers. These are in the Walters Art Gallery, where brilliant examples of Barye's finest casts as well as many modèles can be seen; the Corcoran Gallery, for which over one hundred sculptures were ordered by W. T. Walters, a trustee, from Barye's atelier two years before his death; and the Brooklyn Museum of Art, which acquired the Cyrus J. Lawrence Barye Collection in 1911. (This collection was included in the catalogue of 1889 published by the Barye Monument Association.)

George Lucas, an expatriate from Baltimore, lived in Paris and bought many Barye sculptures for fellow Americans, including W. T. Walters and Cyrus J. Lawrence. Unfortunately his own collection, now on loan to the Baltimore Museum, was not available to us; as it was in storage for the duration of a renovation and expansion program at the Baltimore Museum.

Height precedes length in all sculpture measurements. Fogg measurements are in centimeters. Measurements given in inches from other sources have dimensions in centimeters added in parentheses.

Lengths of sculptures were measured from the longest distance between two points, which often extend beyond the self-bases. Discrepancies in lengths measured by others, therefore, often indicate that the length of the base was measured.

When multiple measurements were used for comparison of similar casts, approximately six were taken from locations which were easily reproduced without having the casts side by side. The differences between comparative measurements were then translated into percentages of relative loss or gain in size, and an average was taken. These averages were compared with the anticipated shrinkage rate of between one and two percent of cast bronze upon cooling.

Conclusions on casting techniques were based on the visual evidence seen on the inside of the casts. In a number of instances the only visible inside area is the base. It is, therefore, possible that some of the figures themselves could have been cast by the lost-wax method, although the bases were sand cast.

Although measurements in the Barye sales catalogue are considered inaccurate, we have found them to be a useful comparative guide to the sculptures, with measurements falling within a few centimeters of the same subject we measured at the Fogg and the other museums. We found them to be consistent from catalogue to catalogue.

Titles of sculptures were taken, when found, from the Barye sales catalogues, and translated into English, with the French titles following. For those sculptures which do not appear in the Barye sales catalogues, such as the early reliefs, we have used titles given in the Barye Monument Association catalogue of 1889.

Since comparatively few sculptures can be dated with certainty, there is no precedent for a chronological sequence of works in either 19th- or 20th-century Barye sales or exhibition catalogues. Most are grouped by collection (e.g., the École des Beaux-Arts catalogues of 1875 and 1889 and the Barye Monument Association catalogue of 1889.) Others are grouped by types of animal in no specific order, as in Barye's own sales catalogues.

For the Fogg's Barye sculpture collection we have chosen arbitrarily a sequence which begins chronologically with known dates of original models (nos. 1 through 19). These are followed by groups of animal types (nos. 20 through 28). No. 30, *Medieval Peasant*, is the only human figure, and no. 31, *Tiger Attacking a Peacock*, is a model which was cast by Barbedienne after Barye's death. The *Striding Lion* (no. 29), although a variant of an 1830s sculpture (*Walking Lion*), appears to derive, in fact, from a late monumental stone sculpture of 1867.

The final eight sculpture entries appear in Appendix A and are numbered I through VIII. With the exception of no. IV, *Panther of Tunis*, which is cast brass, and *Vulture* (no. VIII), which is sand cast, all are late lost-wax casts and most are surmoulages made from edition casts. The final entry, *Vulture*, although an excellent cast, is probably not by Barye.

Bibliography in short form is given for each catalogue entry. Complete bibliographic references along with their short forms can be found in the reference section of the catalogue.

Instead of notes, the same bibliographical short-form references are used in the text for each entry. Two comparatively recent publications often cited are Glenn F. Benge's unpublished dissertation of 1969 on Barye's sculpture in American Collections and Stuart Pivar's *The Barye Bronzes* of 1974, which is profusely illustrated. Both have been especially helpful in locating comparison casts for this publication.

Although the catalogue is devoted mainly to Barye's sculpture in the Fogg Collection, for the sake of completeness we have added a check list of the Fogg's Barye drawings (Appendix B) and entries for the Fogg's two Barye prints (Appendix C). Height precedes width in all drawing and print measurements, which are given in millimeters.

Introduction
Antoine-Louis Barye 1796–1875

Barye was the first and most important of the "animalier" sculptors of 19th-century France. His *Tiger Devouring a Gavial* won a second medal at the Salon of 1831 and his life-size plaster sculpture *Lion and Serpent* created a sensation at the Salon of 1833. Although one of the academic critics coined the word "animalier" as an epithet of contempt, Barye's work inspired a school of animal sculptors which flourished, mainly in France, between 1830 and 1890, and included Frémiet, Méne, the Bonheurs and Moigniez. Animalier sculptors continued to work in many countries well into the 20th century, and bronze animal sculptures, chiefly horses, are still being cast today in large or unlimited editions.

Barye was also one of the leading Romantic sculptors of his time. As in the paintings of Géricault, and particularly of his friend Delacroix, Romanticism inspired Barye's dramatic presentation of animal combats, his studies of wild beasts from life, his interest in exotic and distant places.

But Barye never left France, and, in fact, spent most of his life in and near Paris. Son of a goldsmith, Barye was born in Paris in 1796 and received his early training in metalcraft. Apprenticed at fourteen to Fourrier, maker of metal ornaments for military uniforms, he later studied briefly with the academic sculptor Bosio, and with the painter Gros. After the École des Beaux-Arts turned down his application for a prix de Rome several times, Barye temporarily abandoned his ambition to become a sculptor and worked for eight years for the goldsmith Fauconnier.

Barye's use of animals on decorative objects began his life-long habit of visiting the zoo, as well as the Museums of Zoology and Natural History at the Jardin des Plantes. He read deeply in the natural sciences and his many drawings testify to his practice of making anatomical studies with actual measurements taken from live and dead animals, skeletons, and even from the dissections which he witnessed. (An often quoted letter of 1828 to Barye from Delacroix states, "The lion is dead. Come at a gallop. It is time to get to work." It suggests that both artists attended the dissection of a recently dead lion.) Barye constantly referred to his thousands of graphic notations, his drawings of every possible animal movement. Although he was equally proficient in modeling the human figure, and in later life received commissions for historical and allegorical groups, Barye excelled in his portrayal of wild beasts.

Luc-Benoist in *La Sculpture Romantique* (p. 153) describes Barye's animal sculpture as an "ideal formula—a precise form, an implacable strength determining the most subtle ecstasy. . . . The line which follows the powerful musculature of his wild beasts, even their flabby hides, which elsewhere would seem dead, become volumes created by an interior tension. His calm mastery disguises a secret ardor. . . . Here is a complete artist."

The House of Orleans became Barye's patron in the early 1830s and he soon left Fauconnier to devote himself to sculpture. The model for *Lion and Serpent* was bought by the government, cast in bronze, and placed in the Tuileries Gardens. Barye was made a member of the Legion of Honor.

In 1834 the Duc d'Orléans commissioned an elaborate "surtout de table," or table decoration, on which Barye worked for three years, creating five hunt groups and four animal combat groups. When, in 1837, Barye's hunt groups for the Duke were refused by the Salon jury, along with works by Delacroix, Rousseau and Moine, Barye stopped sending to the Salon until the early years of the Second Empire. The surtout de table itself, planned by the ornamental designer, Chenevard, was never realized. Ballu (pp. 56–58) describes the ill-fated project in great detail. Chenevard's elaborate setting, to be cast in silver and ornamented with semi-precious stones, proved to be so ponderous that the table could not support it. A larger table left no room for chairs, and when the designer demanded that the dining room be enlarged, the plans were abandoned.

In the 1830s Barye purchased a small cottage at Barbizon and spent every summer and autumn there. Corot, Millet, Dupré, and Théodore Rousseau of the "Barbizon School" influenced him and became his friends. Barye's sketches in the forest of Fontainebleau helped him to create imaginary landscapes for his paintings in oil and watercolor of lions, tigers, jaguars, which he had never seen in their native habitats.

After the fall of King Louis-Philippe, a liberal climate prevailed briefly in France, and artists replaced many of the conservative academicians on the Jury of the Salon. Barye reentered the Salon in 1850 and later

received important commissions from the new government, including four allegorical groups for the Louvre and a bas relief of Napoleon III on horseback. In 1855 he won the grand gold medal of honor at the Exposition Universelle and was made an officer of the Legion of Honor.

From 1854 until his death in 1875, Barye held the position of Professor of Zoological Drawing at the Museum of Natural History, where he had spent so much time in his youth. His greatest honor, election as a member of l'Institut de France, came in 1868, seven years before his death. This late recognition by the art establishment of France prompted Barye to remark, "I have waited all my life for [this] patronage and now it comes just as I am putting up my shutters."

In his *Century Magazine* article of 1886 Henry Eckford mentioned the "quantities of drawings, watercolors and oil paintings and careful measurements of animals" which were included in the École des Beaux-Arts exhibition of November 1876. "A beast could not die at the Jardin des Plantes without Barye being on its coroner's jury and at its post-mortem," he wrote.

Charles Blanc, in *Les Artistes de Mon Temps* (pp. 391–392), wrote that the posthumous Barye Beaux-Arts exhibition was imposing in sculpture but also revealed the immense labor that went before the realization of these great imaginative works. "He was a patient anatomist, a romantic with classical knowledge. He had studied in depth proportions of men and animals, the anatomy based on knowledge of the skeleton, the measurement of bones, the dissection of animals. He modeled each part separately." He added that "Barye's animals were as beautiful by the grandeur of their silhouette as by the details rendered with such energy."

The Barye Bronzes

Snubbed by the academic art establishment in 1837, Barye turned to the public for patronage by creating small bronze animals suitable for the salons and studies of the newly rich bourgeoisie.

In 1839 he established his first workshop with borrowed money and began to issue sales catalogues. Eye witness accounts and conversations with his employees emphasize Barye's perfectionism as a craftsman. He followed every step of the bronze casting process from model to molding to casting, to chasing and engraving, and finally to patinating the bronze, often performing these tasks himself. To obtain consistent quality of minute surface details of fur and feather, Barye made bronze casts of his plaster and wax models, which, in turn, served as modèles for casting the entire series of a bronze edition. This perfectionism, although financially disastrous, produced the Barye bronze, that remarkable object with sharpness of every detail, and a glorious blending of patinas.

Although the lost-wax method of casting was considered the optimum, lack of trained craftsmen in Barye's time in France made it more practical and less expensive to use sand casting. Arsène Alexander explains (p. 91) that Barye "tried all methods, even at the sacrifice of losing money. The ideal was that admirable cast made by the lost-wax process. But how could he sell a piece so expensively that it would cover the cost of this operation and make enough profit to live on?" And Ballu, describing Barye's disappointment in the casting of the *Lion assis* (p. 98), recounts that "another cause of discontent was the method of casting. Actually the *Seated Lion* was sand cast and Barye preferred the lost-wax cast which produces naturally, without interpretation, without corrections, the work as it emerges from the hands of the artist, keeping even the print of his thumb."

Barye's first monumental work, the *Lion and Serpent* of 1833 was, in fact, cast by the lost-wax method by Gonon, who proudly inscribed it "cast by Honoré Gonon and His Two Sons 1835." The five hunt groups ordered for a table decoration by the Duc d'Orléans in 1834 were unique lost-wax casts also made by Gonon and his sons. It is significant that Gonon died in 1839, the year Barye established his first foundry for the casting of his own works. Most of Barye's bronzes were sand cast, usually in at least two pieces. The bases were cast separately and mechanically fastened to the sculptures.

Barye's sales catalogue, issued from Rue de Boulogne, No. 6 and dated 1847–1848, has the following notes:

> "1. Each bronze carries visibly the number of the proof and the mark of the author.

2. The bronzes of the second series can serve as clocks for the office or bedroom and those of the third for living room clocks."

The number of the proof and the mark of the author were made with a steel punch containing a miniature BARYE in block letters and the number. De Kay (p. 56) comments that "in the end he found numbering copies impracticable and gave it up. Very few pieces are stamped above 100." The note about Barye's stamp does not appear in his five other sales catalogues.

In 1840 Barye signed his first contract with Émile Martin who became his business partner and undoubtedly invested money in Barye's various foundries, salesrooms, and ateliers at six different addresses. In 1846 he signed a second contract with Martin, but "Barye and Company" soon failed financially. In 1848 his creditors took over Barye's models and tools, the only tangible assets of the bankrupt company. Martin's records and account books indicate that some of the models and presumably their copyrights were sold to other foundries even while Barye maintained his own foundry and salesroom. Barbedienne was among the better of these and sometimes equaled the quality of Barye's own casts. Nevertheless, as Barye was unable to supervise this proliferation of editions and casts, the perfection he sought was often lost to the mediocrity of inconsistent craftsmanship.

Barye managed to buy back his modèles from Martin in 1857 and retained them until his death in 1875, when they were dispersed at the sales of his estate. Barbedienne acquired 125 of the modèles which he used to produce edited casts until after the First World War. (Posthumous Barbedienne editions marked "F. Barbedienne" sometimes carried a gold inset marked "FB" and were usually of good quality.) Seventy-eight of the modèles were acquired by Hector Brame, who hired Barye's chief workman and offered some excellent casts. But this project failed also and those who took it over turned out poor casts. Other posthumous editions emanated from plasters, waxes, and unedited bronzes sold at the two Barye sales in 1876 and 1884 and resulted in unmarked casts of varying quality.

Henry Eckford, writing in the February 1886 issue of Century Magazine (p. 486), deplored the ignorance of buyers at the sale of Barye's works at the Hôtel Drouot in 1876, who "class all small bronzes as paper weights." He further stated that "the professionals were there, and secured for the foundries to which Barye disdained to entrust his work, a supply of beautiful original models. . . . The world is full of Barye bronzes now; but those we see are rarely the fine examples. The jewels are those which Barye designed and cast for some friend or patron, over which he lingered lovingly, touching and filing the work, and giving it the full benefit of the master's hand."

Eckford also reports the rumor that "false Baryes were cast in New York twenty years ago. It is certain that a parasitical workman who lived on Barye's name in Paris had his shop visited by the police before the sculptor died."

Barye Sculpture in the United States

Thanks to two gentlemen from Baltimore, some of the finest Barye bronzes, including modèles, can be seen in the United States. In fact, in his 1889 biography of Barye, Arsène Alexandre complained that "today one looks hard for the signature of Barye, and original casts are subjects of dispute. But a considerable quantity of the most beautiful pieces are no longer in France and will not return. America has eagerly bought them up . . . and it is at Baltimore that one must look for a monument worthy of the artist. Thanks to the enthusiastic generosity of Mr. Walters, collector of the most beautiful casts known, in one of the squares of Baltimore are erected the Lion and Serpent and the four groups of the Carrousel. The museum of Washington [the Corcoran Gallery of Art] is equally rich in bronzes of Barye, much richer than our national museum which possesses only two works by him." (Thanks mainly to the donations of Zoubaloff and Thomy-Thiery, the French museums today have fine collections of Barye sculpture, paintings, and drawings, all of which were exhibited by the Louvre in 1956–1957.)

George A. Lucas, an expatriate Baltimorean, introduced W. T. Walters of Baltimore to Barye's work. Walters first bought a Barye drawing in 1861 but, after visiting the studio with Lucas, began to buy bronzes. In 1837 Walters, who was chairman of the Acquisition

Committee for the Corcoran Gallery, Washington, ordered from Barye's atelier a cast of every available subject, some 120 in all, for the museum. In the preface to his collection of critical writings on Barye, Walters relates: "To have been enabled to give this commission was one of the most agreeable acts of my life in relation to my art experience, and it was not the less so to the artist, who observed, 'My own country has not done this for me!'"

Lucas continued to buy Barye sculpture for Walters' own collection, including the *Walking Lion* in silver, and a series of modèles. Later Walters succeeded in reuniting four of the five great Hunt groups (unique casts in lost-wax), from the "surtout de table" of the Duc d'Orléans, which were dispersed at the sale of the effects of the Duchesse d'Orléans in 1853.

Walters' Barye collection and his enthusiasm for the artist resulted in the opening of the Barye Room in his Baltimore residence in 1885 and the memorial exhibition sponsored by the Barye Monument Association in New York in 1889. Walters' son, Henry, augmented the collection, which now numbers almost 200 objects including bronzes, oil paintings, and watercolors and is housed in the Walters Art Gallery, Baltimore.

The Fogg's Barye Sculpture

The Fogg Art Museum has one of the larger collections of Barye sculptures to be found in American museums, some thirty-nine in all. They are gifts of four donors—Mrs. Robert H. Monks in 1927, Grenville L. Winthrop in 1943, the Henry Dexter Sharpe Collection, gift of Mrs. Sharpe, in 1956, and one sculpture given by Mrs. Deborah L. Riefstahl in 1957.

Unfortunately none of these sculptures was acquired, like those of Lucas and Walters, from Barye's atelier during his lifetime, and few came to us with a provenance. Mr. Winthrop acquired our most significant Barye sculpture, the plaster and wax model of *Tiger Attacking a Peacock*, as well as a wax deer. The Sharpe gift of twenty-eight bronzes forms the largest part of the Fogg's collection. It is an excellent study collection, for it runs the gamut of 19th-century bronze quality including good examples of sand casts made in editions by competent 19th-century foundrymen, mediocre casts lacking surface detail, and even outright surmoulages (unauthorized casts made from

another cast rather than from the original model).

We have here in microcosm the tremendous problem of 19th-century bronzes. Lacking identification or foundry marks and numbers, we can only judge the quality of the cast itself. This is difficult in isolation, but much more revealing when a cast is compared with an original modèle or a cast signed by Barye himself.

A trip to the Walters Art Gallery to compare measurements of Walters' magnificent casts and modèles, with certain puzzling Fogg casts proved enormously helpful. Comparisons were made also of certain Fogg subjects with those in the Corcoran Gallery (acquired from Barye's atelier two years before his death) and those in the Brooklyn Museum of Art, acquired in 1911 from the Cyrus J. Lawrence Collection. De Kay has written (p. 58) "A great gathering of works by Barye . . . is valuable . . . for the chance it affords to compare the same piece in its different shades and varieties of patinas." As noted in the individual entries, we seldom found two casts of a subject with the same patina.

13

Definition of Technical Terms

BRONZE CASTING

The *lost-wax* (*cire perdue*) process may be sub-divided into "direct" and "indirect" casting. The direct method is a simple substitution resulting in a unique cast. A unique wax model with attached "gating" and "venting" systems is surrounded by a mold made of a refractory material, which is then heated to melt off the wax. The resulting space is filled with molten metal, and the wax model is therefore replaced with a bronze one.

The indirect method is identical in the metal-casting stage, but the wax model is mold-made and can be duplicated as often as necessary to make an edition.

Sand casting is normally an "indirect" process involving a reusable model, and the resulting metal cast often is not unique. A sand piece-mold is fashioned on the model. It is then disassembled, the model is removed, and molten bronze is poured in the resultant space. Sand-cast bronzes are often made in several sections which are later joined in the finishing process.

Both the lost-wax and the sand-cast methods of casting sculptures in the round, usually require an inner core of a refractory material, sometimes removed after the casting, so that the bronze cast will be hollow, thin-walled, and light weight.

Lost-wax casting was predominant in Southern Europe during the 19th century, whereas in Northern Europe sand-casting was the more commonly used method. Lacking craftsmen skilled in the many stages of the lost-wax process, Barye and other French sculptors of the period found the sand-cast method more economical. Toward the end of the century, Italian craftsmen brought the lost-wax technology to France, where it became more widely used.

CHASING OR COLD-WORKING

Bronze is poured molten at a temperature of 2000 degrees Farenheit. When a cooled cast is removed from its mold the surface is sometimes disfigured with voids, lumps, mold lines and has attached gates and vents which must be removed. *Chasing* is the process of removing these superfluous or disfiguring elements. The "ciseleur" or chaser was an important craftsman in early 19th-century foundries, for he also often embellished casts during this process with decorative detail on the surface.

PATINATING

The *patina* of a bronze cast refers to either naturally or artificially induced alteration of the surface. It can be the result of natural chemical changes in the surface, produced by exposure to air or handling, or it can be induced intentionally by the use of a variety of reactive chemicals applied to the metal with heat from a torch to accelerate the reactions. Most 19th-century bronzes were patinated this second way, and such rich, artificially-produced color combinations as black and green, and brown and gold, greatly enhanced the finished bronze sculpture. Barye was famous for the varied patinas of the bronzes made under his supervision. The "patineur" like the "ciseleur" was an important craftsman in the 19th-century foundry. Differences in color or patina often occurred from cast to cast in the same edition, either to please a specific buyer, or to reflect the art of an individual craftsman.

SURMOULAGE

A cast using another cast as a model instead of the artist's original, a surmoulage is usually unauthorized and considered spurious. Because molten bronze shrinks while cooling, surmoulages in bronze usually measure one and a half to two percent overall smaller than the authorized edition casts.

Barye used bronze "modèles" (models) for casting his large editions because of their durability. All Barye edition casts are technically surmoulages. An unauthorized Barye surmoulage made from an edition cast is, therefore, twice removed from the bronze modèle and would show at least a three to four percent shrinkage factor when compared to the modèle. Larger percentages found on some of the bronze surmoulages in this catalogue are probably due to shrinkage of the wax as well as the bronze, since all were cast by the lost-wax method.

Early Relief Plaques (1–4)

Sand cast with brown patina, all four relief plaques are good casts in high and low relief, with evidence of cold working, particularly where the background has been gouged down to bring out the relief forms.

They are considered early Barye works. The Metropolitan Museum dates their casts 1824–1826, with the exception of the *Running Elk* (named *Virginia Stag With Antlers* in the *Metropolitan Picture Book*), which is dated 1831.

De Kay, on p. 26, writes that in 1831 "Barye was still casting bas-reliefs of small size, generally square, which are apparently designed for ornaments to clocks or pieces of furniture. At the time they had no higher purpose, whilst now they are carefully framed as works of art."

None of the Fogg's small reliefs appears in the Barye sales catalogues, but all are included in several other American museum collections. In addition, three of the reliefs are listed in the Sichel Sale of 1886 at the Hôtel Drouot, two are in the École des Beaux-Arts Exhibition Catalogue of 1889, and three are to be found in the collection of George A. Lucas, now in the Baltimore Museum of Art.

According to Pivar (p. 30) Barye, who experimented with "galvano-plastique" (electrotyping), made small relief plaques using this method, which he later abandoned. This could account for their absence from his sales catalogues.

Pointer and Ducks

Bronze relief plaque, 10.1 x 14.1 cm.
Markings:
Incised lower left: BARYE
Henry Dexter Sharpe Collection, 1956.153

Benge lists casts of this relief in the following
American museum collections: Walters, Brooklyn,
Fogg, Wadsworth Atheneum, Metropolitan, and
Philadelphia. There is also a cast in the George A.
Lucas Collection, on loan to the Baltimore Museum.

A cast of this subject made by the "galvano-plastic
process" is listed in the catalogue of the Barye
Monument Association exhibition in 1889 as no. 267,
in the Cyrus J. Lawrence Collection. Another cast,
belonging to Samuel P. Avery, is listed as no. 352.

However, an examination of the Lawrence cast, now
in the Brooklyn Museum (no. 10.183), revealed that it
is a lost-wax bronze cast not a "galvano-plastic"
(electrotype). Furthermore, the quality surpasses the
bronze cast in the Fogg with crisper detail on the
flying duck, the flowers beneath the dog, and the
small duck on the lower left corner of the relief. There
is no BARYE signature. The dimensions are 10.5 x
15.5 cm and the patina is light brown.

Bibliography: New York, 1889, nos. 267, 352;
Baltimore, 1911, no. 460; Metropolitan, 1940, fig. 5;
San Antonio, 1965, no. 4; Benge, 1969, pp. 310–312,
no. 191b, fig. 42; London, 1972, no. 26; Pivar, 1974,
p. 249, R16.

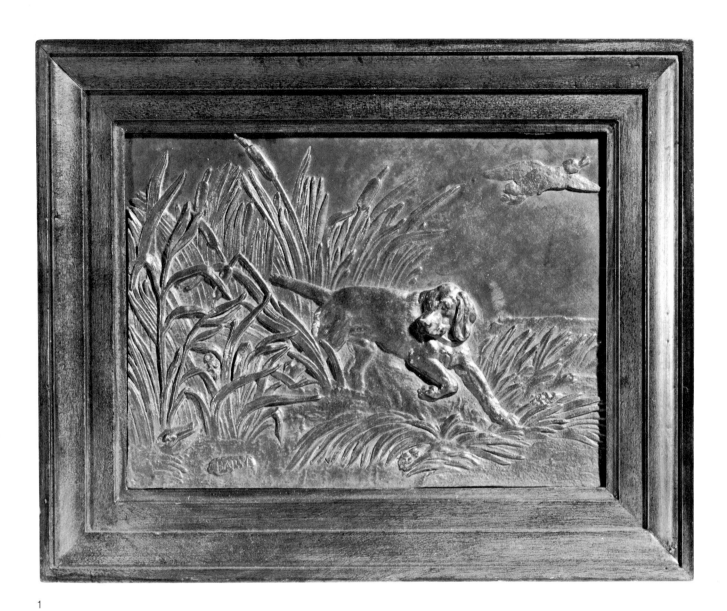

1

2
Running Elk

Bronze relief plaque, 10 x 14.6 cm
Markings:
Incised on lower left corner: BARYE
Henry Dexter Sharpe Collection, 1956.154

A bronze strip about 1 cm wide has been added to
the right edge of this relief by cold-working after
casting.

A cast of this subject appears in the 1886 Paris cata-
logue of the Sichel Sale as no. 67, *Cerf courant*. There
is also no. 66, *Cerf de Virginia*, which appears in
several Barye sales catalogues and sometimes has
been confused with the *Running Elk*.

In the 1911 Maryland Institute catalogue of the
George A. Lucas Collection, a cast is listed as
Running Elk, no. 480.

Benge lists this relief as *Elk Running in a Forest* (*un
cerf d'Amerique*) in the following American museum
collections: Walters, Brooklyn, Fogg, Wadsworth
Atheneum, Philadelphia, and Corcoran Gallery of Art.

*Bibliography: Paris, 1886, no. 67; De Kay, 1889, p.
26; Baltimore, 1911, no. 480; San Antonio, 1965, no.
5; Benge, 1969, pp. 310–312, no. 186d, fig. 43; Pivar,
1974, p. 249, R17.*

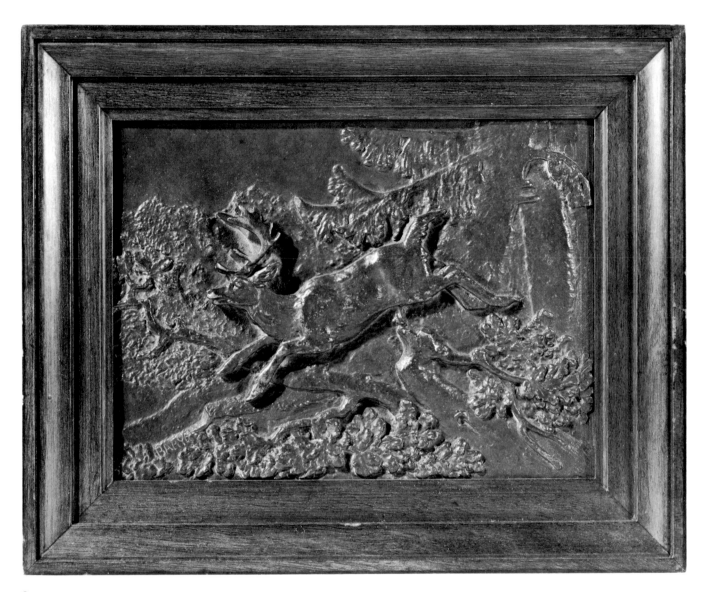

2

3
Eagle with Serpent

4
Eagle with Chamois

Bronze relief plaque, 10.3 x 14.5 cm
Markings:
Incised lower left: BARYE
Henry Dexter Sharpe Collection, 1956.155

A similar cast of this relief in the Metropolitan Museum is entitled *Lammergeier and Serpent*, and the same title is used by De Kay. In the 1911 exhibition catalogue of the George A. Lucas Collection, held at the Maryland Institute of Art, the relief is listed as *Laemmergeyer and Serpent* (no. 482).

It first appears in the Paris Sichel Sale of 1886 as no. 68 *Aigle tenant un serpent*, described as a rare old cast with a beautiful light brown patina. Dimensions given are 10 x 15 cm.

In the Barye Monument Association catalogue of 1889 the Walters cast is no. 99 and that belonging to Samuel P. Avery is no. 353. A cast from the Bonnat Collection is no. 254 in the 1889 École des Beaux-Arts catalogue, and no. 387 of the same catalogue is a cast owned by Fannières frères.

Benge lists it in the following American museum collections: Walters, Brooklyn, Fogg, Wadsworth Atheneum, Metropolitan, and Philadelphia.

An examination of the Brooklyn Museum's cast (no. 10.188) produced the measurements 10.4 x 14.5 cm, or the same as the Fogg's. The BARYE signature appears in the same general area as it does on the Fogg cast, although it is incised along the ridge of the rock instead of on the rock's surface. On the upper left corner of the back of the relief the founder's name "Eck et Durand" appears in raised letters, confirming that this is a sand cast. It is a good but not superb cast, with a dark brown and black patina.

Bibliography: Paris, 1886, no. 68; Paris, 1889, nos. 254, 387; New York, 1889, nos. 99, 353; De Kay, 1889, p. 15, no. 7 (ill.); Baltimore, 1911, no. 482; Metropolitan, 1940, fig. 3; Paris, 1956–1957, no. 84; San Antonio, 1965, no. 3; Benge, 1969, pp. 310–312, no. 119b, fig. 40; Paris, March 1972, no. 42; Paris, June 1972, no. 46; Pivar, 1974, p. 248, R14.

Bronze relief plaque, 10.2 x 14.1 cm
Markings:
Incised lower left: BARYE
Henry Dexter Sharpe Collection, 1956.156

This relief is no. 69 in the Paris Sichel Sale of 1886. It is described as an "old cast, very rare—beautiful light brown patina." The dimensions given are 10 x 15 cm. It appears twice in the Barye Monument Association catalogue, as no. 100 from the Walters Collection and no. 354 from the Samuel Avery Collection. It also appears twice in the École des Beaux-Arts catalogue of 1889, in which it is no. 253 from the Bonnat Collection and no. 388 owned by Fannières frères. In the 1911 Maryland Institute exhibition catalogue of the Lucas Collection, there are two casts of *Eagle and Chamois*: no. 458 (5 x 7½″) and no. 481 (4½ x 6″).

Benge lists this subject in the collections of the Brooklyn, Fogg, Wadsworth Atheneum, and the Metropolitan Museums.

Bibliography: Paris, 1886, no. 69; Paris, 1889, nos. 253, 388; New York, 1889, nos. 100, 354; De Kay, 1889, p. 15; Baltimore, 1911, nos. 458, 481; Metropolitan, 1940, fig. 2; Lengyel, 1963, ill.; San Antonio, 1965, no. 1; Benge, 1969, pp. 309–312, no. 115b, fig. 41; Paris, March 1972, no. 43; Pivar, 1974, p. 248, R15.

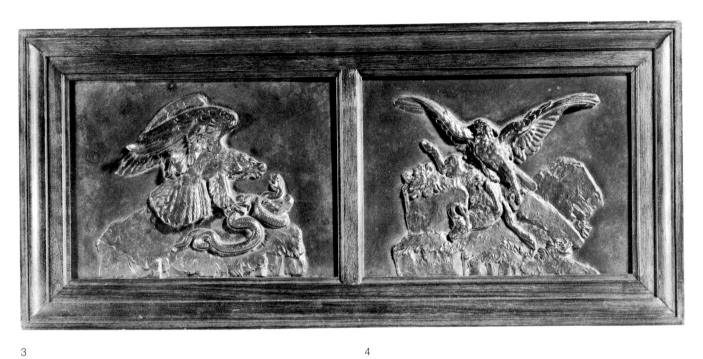

3 4

5
Spaniel and Duck

Bronze, 7.6 x 12.1 cm
Markings:
Top of base, proper right rear corner: BARYE
(incised)
Inside base: tape with typed number 2.9.48 A. L.
Sharpe
Henry Dexter Sharpe Collection, 1956.162

This is a good cast with sharp detail. It has been
sand cast in at least three pieces and has a brown
and black patina. The Barye signature appears to
have been added after the casting, rather than cast
through from the model. It is placed on the diagonal,
which is not typical of Barye. The sculpture is exten-
sively chased, particularly on the wings of the duck,
which has feather details added after the casting. The
dog's fur, however, has been cast from the model.

The *Spaniel and Duck* does not appear in any of the
Barye sales catalogues. It is, however, similar in
composition to *Spaniel Pointing a Rabbit* and *Pointer
and Pheasant*, which are listed in all six Barye sales
catalogues.

The Walters Art Gallery has two versions of *Spaniel
and Duck*, one which measures 13.4 x 21.2 cm (no.
29.97) and a smaller one, measuring 7.3 x 11.4 cm
(no. 27.54). There are significant differences in
composition between the two. The larger version has
an oval base; the small version's base is square. The
dog's posture is significantly different in the two
versions; in the larger version it is more arched, with
the head turned down.

The Walters' smaller version of *Spaniel and Duck* is
similar to the Fogg's. Both have square bases and the
dogs are the same. The dimensions also are close.
The treatment of the duck, however, is different,
showing variation particularly in the proper right wing.

A *Spaniel and Duck* appears twice in the Barye
Monument Association catalogue. No. 80 of the
Walters Collection is described as a reduction
measuring 2¾ x 4″ (8 x 10.1 cm). No. 305 from the
James F. Sutton Collection has the dimensions 5½ x
8″ (14 x 20.3 cm). Both dimensions are different from
those of the Fogg's cast.

Benge lists the Fogg's cast with the Walters' (p. 527,
no. 194a) under the title "*Spaniel and Duck,* epagneul
en arrêt sur un faisan." He gives the Walters cast the
dimensions 9 x 18 cm.

*Bibliography: New York, 1889, nos. 80, 305; Benge,
1969, p. 311, no. 194a, fig. 53; Pivar, 1974, p. 114,
A28.*

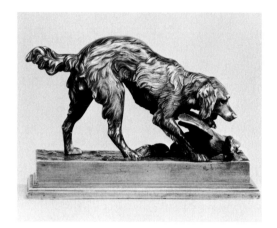

5a Spaniel and Duck (no. 27.54)
Walters Art Gallery, Baltimore

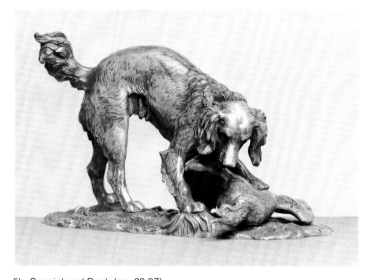

5b Spaniel and Duck (no. 29.97)
Walters Art Gallery, Baltimore

5

6
Startled Hare (Lièvre effrayé)

Bronze, 4.3 x 5.5 cm
Markings:
Side of base, proper right rear: BARYE (incised)
Side of base, proper left side: F. BARBEDIENNE
(incised)
Under side of base: 649 (cast in)
Gift of Mrs. Robert H. Monks, 1927.100

Probably a sand cast, with a green-brown patina, this tiny rabbit has the foundry name F. BARBEDIENNE incised on the left side of the base in addition to the usual BARYE signature on the opposite side of the base. The Fogg's bronze has been reproduced in "Museum-Stone" by Museum Pieces, Inc., in an unlimited edition and is illustrated on p. 33 of their catalogue.

The *Startled Hare* is one of a group of small animals and birds considered to be early works similar to Barye's decorative finials for tureen covers, clocks, inkwells, and other useful objects, which he made while working for the goldsmith Fauconnier.

De Kay, p. 26, writes ". . . as late as 1847 he was producing small bronzes, avowedly for ornamenting the clocks of offices and private houses; some merely as bronzes to lay on top of a clock, others to affix to the front and sides."

A cast in the Brooklyn Museum (no. 10.212) has essentially the same dimensions (4.6 x 5.8 cm). It is a good sand cast with a dark green patina and the fur on the surface of the animal is more sharply defined than on the Fogg's cast. The BARYE name appears in the same place as the Fogg's, but there is no foundry mark.

In Benge's 1969 dissertation this rabbit is mistakenly listed as no. 77c, p. 440 "Rabbit, Ears Raised." It should be listed as "Crouching Rabbit, Ears Lowered" no. 79, p. 441. The small rabbits, however, are difficult to identify as there seem to have been many variations made, both by Barbedienne and Barye himself. This crouching rabbit is listed as no. 196 in the last Barye sales catalogue (Quai des Célestins, 4). The bronze modèle was offered as no. 649 in the 1876 Barye sale at the Hôtel Drouot. A modèle belonging to Barbedienne is no. 80 in the École des Beaux-Arts catalogue of 1889. Pivar illustrates the Philadelphia Museum cast (A191, p. 233).

Bibliography: Quai des Célestins, 4, 1865, no. 196; Paris, 1876, no. 649; Paris, 1889, no. 80; Alexandre, 1889, p. 59 (ill.); Barbedienne, 1893, p. 5; Baltimore, 1911, no. 509; Benge, 1969, pp. 310–312, no. 79, fig. 52; Paris, March 1972, no. 38; Pivar, 1974, p. 233, A191.

6

7
Seated Hare (Lièvre assis)

Bronze, 8.1 x 5.1 cm
Markings:
Top of base, proper left rear: BARYE
Side of base, proper right side: F. BARBEDIENNE
(incised)
Gift of Mrs. Robert H. Monks, 1927.99

This small sculpture was sand cast in one piece, including the base. It has a green patina and was cast by the Barbedienne foundry, whose name appears on the base opposite the BARYE signature.

Comparison with a cast in the Walters Art Gallery (no. 27.5) carrying only the Barye signature shows that the Walters example is slightly smaller, measuring 6.1 x 3.1 cm. The Brooklyn Museum has a Barbedienne cast (no. 10.213) with the same dimensions and markings as the Fogg's. It is a good quality sand cast, made in one piece, and has a transparent green patina.

The subject appears in the last Barye sales catalogue with dimensions 8 x 5 cm, or almost the same as the Fogg's. The bronze modèle and its plaster were sold at the Hôtel Drouot Barye sale of 1876, probably to Barbedienne. In fact, a modèle belonging to Barbedienne is listed as no. 81 in the École des Beaux-Arts catalogue of 1889.

Bibliography: Quai des Célestins, 4, 1865, no. 195; Paris, 1876, no. 648; Paris, 1889, no. 81; New York, 1889, no. 94; De Kay, 1889, p. 129 (ill.); Barbedienne, 1893, p. 5; Paris, 1956–1957, no. 72, pl. IX; Benge, 1969, pp. 310–313, no. 39b, fig. 48; Paris, June 1972, no. 1; London, 1972, no. 3; Pivar, 1974, p. 233, A190.

7

8
Stork with a Snake (Marabout)

Bronze, 13 x 6.5 cm
Markings:
Top of base, proper right rear: BARYE
Side of base, proper left rear: F. BARBEDIENNE
(incised)
Henry Dexter Sharpe Collection, 1956.144

This small sculpture appears to be sand cast in one piece. The patina is black with green. Besides the usual BARYE signature on top of the base, it bears the foundry signature F. BARBEDIENNE, which is incised.

Benge considers it one of the early works of the 1820s, and indeed the small scale, rather static pose, and decoratively detailed surface appear to link the *Stork* with the small animal decorations Barye created for the goldsmith Fauconnier.

Benge lists only one other example in American collections, a cast in the Worcester Art Museum.

This sculpture, with the title *Marabout*, is listed as no. 224 with a height of 13 cm in Barye's last sales catalogue (Quai des Célestins, 4). It appears twice in the Hôtel Drouot Barye Sale of 1876: as no. 552, under "Wax Sketches," and as no. 646, a "bronze model with its plaster." Barbedienne probably acquired the model at this sale, for a modèle belonging to Barbedienne is listed as no. 62 in the École des Beaux-Arts catalogue of 1889 and a wax belonging to Barbedienne is listed as no. 654.

Stork with a Snake is similar in scale and treatment to *Stork Standing on a Turtle* which appears in all the Barye sales catalogues. Benge lists casts of the stork and turtle subject in the following American museums: Walters, Brooklyn, Wadsworth Atheneum, and Philadelphia.

Bibliography: Quai des Célestins, 4, 1865, no. 224; Paris, 1876, nos. 552, 646; Paris, 1889, nos. 62, 654; New York, 1889, no. 318; Barbedienne, 1893, p. 7; Baltimore, 1911, no. 552; Benge, 1969, pp. 310–312, no. 152a, fig. 60; Pivar, 1974, p. 226, A181.

8

9
Kevel Antelope (Kevel)

Bronze, 11.1 x 10.8 cm
Markings:
Top of base, proper left center: BARYE
Side of base, proper right center: F. BARBEDIENNE,
FONDEUR (incised)
Gift of Mrs. Robert H. Monks, 1927.98

This antelope is a good sand cast without much cold working. The patina is brown.

In addition to the usual BARYE on top of the base, the foundry signature F. BARBEDIENNE, FONDEUR is incised.

Benge includes this sculpture with Barye's early work of the 1820s, and it is indeed less supple and detailed than Barye's later sculpture. However, he erroneously lists the Fogg's cast under *Gazelle d'Ethiopie* (p. 409, no. 35b) whereas he mentions only the collection of the Philadelphia Museum of Art for the Fogg's sculpture.

There is also a cast of the Fogg's *Kevel Antelope* in the Brooklyn Museum of Art, entitled *Kevel Gazelle* (no. 10.127). Upon examination the Brooklyn Museum's cast measures a centimeter shorter than the Fogg's (10.1 x 10.6 cm), possibly because the horns are bent. It has no foundry mark, but the BARYE signature is in the same location as on the Fogg's cast. The patina is green over reddish brown and the cast quality is good. It might possibly be a lost-wax rather than a sand cast.

The *Kevel* is listed in the three Barye sales catalogues issued between 1855 and 1865 with the same height as the Fogg's Barbedienne cast. The bronze modèle and its plaster were offered as no. 637 in the 1876 Barye sale at the Hôtel Drouot. A modèle belonging to Barbedienne is no. 74 in the École des Beaux-Arts catalogue of 1889, which also lists two bronze casts, nos. 480 and 487.

Bibliography: Rue de Fossés-Saint-Victor, 13, 1855, no. 101; Quai des Célestins, 10, 1855, no. 126; Quai des Célestins, 4, 1865, no. 124; Paris, 1876, no. 637; Paris, 1886, no. 51; Paris, 1889, nos. 74, 480, 487; New York, 1889, nos. 320, 372; De Kay, 1889, pp. 15–16; Ballu, 1890, p. 172; Barbedienne, 1893, p. 6; Benge, 1969, pp. 308, 310, no. 49, fig. 34; New York, 1971, no. 1 (ill.); London, 1972, no. 61 (ill.); Paris, June 1972, no. 7; Paris, March 13, 1973, no. 11 (ill.); Pivar, 1974, p. 196, A138.

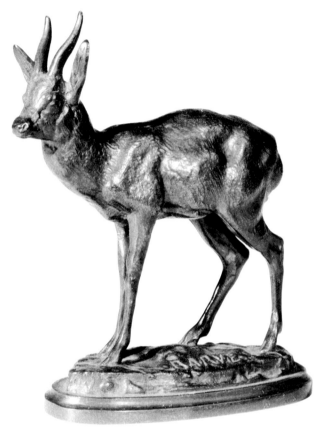

9

Stag with Leg Raised (Cerf, la jambe levée)

Bronze, 19.9 x 16.7 cm.
Markings:
Top of base, proper left center: BARYE
Inside of base: H. D. S. from S. D. K.
Henry Dexter Sharpe Collection, 1956.145

Sand cast in two parts, this sculpture has excellent
detail. Particularly noteworthy are the surface texture
of the animal's fur, its alert expression, and the deli-
cacy of its legs and hooves. The patina is black and
green.

The Fogg cast compares favorably with the one in the
Walters Collection (no. 27.90). Comparative
dimensions are the same, indicating that they were
probably from the same edition. The Walters cast,
however, has a brown patina.

This subject is listed in all six Barye sales catalogues
with the dimensions 20 x 16 cm. In the last three
Barye sales catalogues it is listed as a pendant with
Cerf qui écoute (Listening Stag) with the same dimen-
sions. It is no. 640 in the 1876 Hôtel Drouot Barye
sale, where it is offered as a bronze modèle with
its plaster. In the École des Beaux-Arts catalogue
of 1889, no. 57 is a bronze modèle loaned by
Barbedienne and bronze casts are listed as nos. 226,
282, and 394.

*Bibliography: 12, Rue Chaptal, n.d., no. 21; Rue Saint-
Anastase, 10, n.d., no. 21; Rue de Boulogne, No. 6,
1847–1848, no. 21; Rue de Fossés-Saint-Victor, 13,
1855, no. 90; Quai des Célestins, 10, 1855, no. 115;
Quai des Célestins, 4, 1865, no. 113; Paris, 1876, no.
640; Paris, 1889, nos. 57, 226, 282, 394; New York,
1889, nos. 67, 432; De Kay, 1889, p. 65;
Barbedienne, 1893, p. 5; Baltimore, 1911, no. 499;
Benge, 1969, pp. 349–351, no. 89c, fig. 193; New
York, 1971, no. 13 (ill.); London, 1972, no. 43; Pivar,
1974, p. 171, A108.*

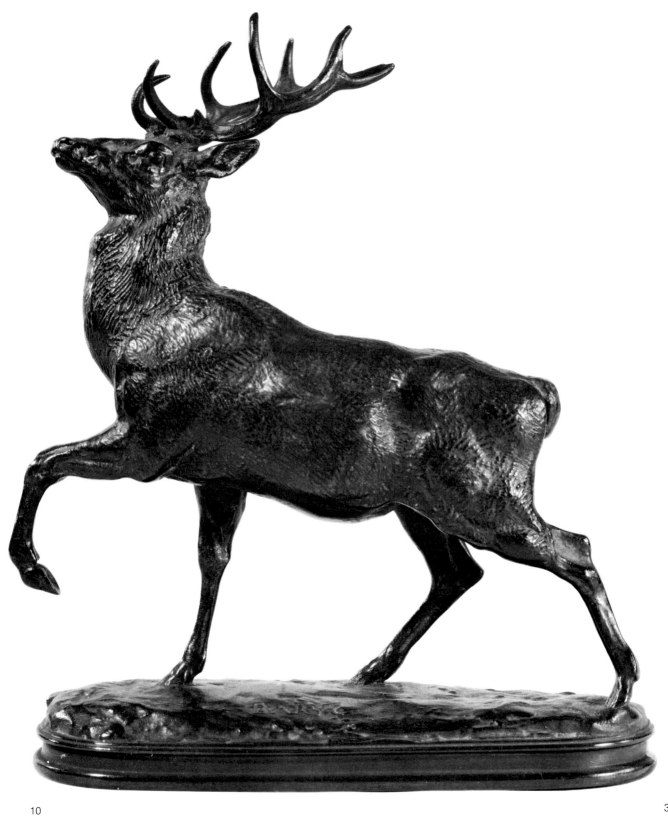

11
Stag at Rest (Cerf au repos)

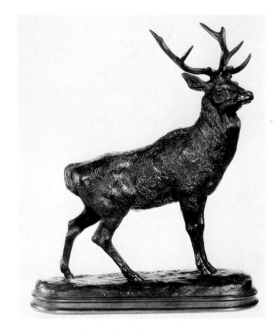

Bronze, 22.2 x 21.4 cm
Markings:
Top of base, proper left rear: A. L. Barye
Inside of base: 746 (scratched)
Henry Dexter Sharpe Collection, 1956.146

This sculpture is sand cast in two parts and has a green patina. Like most Barye sculptures, the base has been sand cast separately and mechanically fastened to the animal. On this cast, the slots where the stag's hooves have been fitted into the base are clearly visible.

Benge mistakenly lists this sculpture under 95, *Stag Walking, Right Foreleg Raised*, whereas it should have been listed under 94, *Stag Standing at Rest*, where he mentions only the Walters cast (with the dimensions 24 x 19 cm) and a cast in the Philadelphia Museum of Art.

The *Cerf qui écoute* (*Listening Stag*) is in the Brooklyn Museum's Collection (no. 10.143) and appears to be a variation of the *Stag at Rest*. The position is more alert, with the head raised and turned to the proper right side, and the front legs are close together. The markings are of special interest. "BARYE 1838" cast through from the wax model, can be seen on top of the base, proper left center. In addition, Barye's personal stamp, a miniature BARYE and the number 36, is clearly visible on top of the base, in the proper right rear corner. It is an excellent sand cast in one piece, with a brown patina.

Stag at Rest is listed in the last three Barye sales catalogues with the same dimensions as the Walters cast (24 x 19 cm) or somewhat larger than the Fogg's. It is no. 639 under "Bronze modèles" in the Hôtel Drouot Barye sale of 1876.

11a Listening Stag (10.143)
The Brooklyn Museum, Purchased by Friends of the Museum by Special Subscription

11b *Detail of 11a*

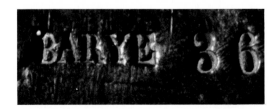

11c *Detail of 11a*

Bibliography: Rue de Fossés-Saint-Victor, 13, 1855, no. 88; Quai des Célestins, 10, 1855, no. 113; Quai des Célestins, 4, 1865, no. 111; Paris, 1876, no. 639; Paris, 1884, no. 61; New York, 1889, nos. 65, 369, 383; Benge, 1969, pp. 349–351, no. 94, fig. 191; Pivar, 1974, p. 170, A106.

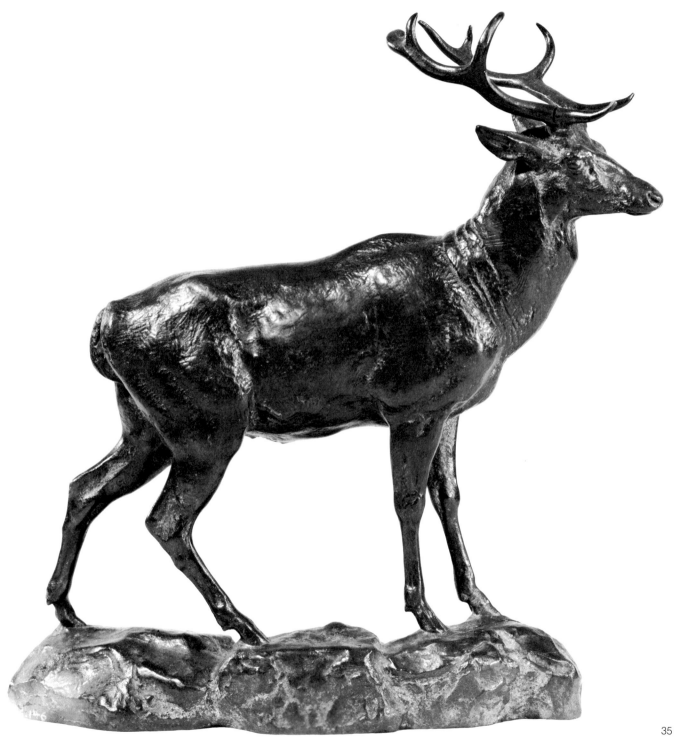

12
Braying Stag (Cerf bramant)

Bronze, 23 x 21.3 cm
Markings:
Top of base, proper right rear: BARYE
Henry Dexter Sharpe Collection, 1956.147

Sand cast in one piece, this sculpture has a dark green patina.

An example on display in the Walters Art Gallery was not measured but appears smaller. (Benge gives the Walters dimensions as 21 x 18 cm.) Stuart Pivar, on p. 43 of his catalogue raisonné, cites two sizes: one 21 cm high, another 14 cm high.

Barye himself often offered several sizes of a subject in his sales catalogues. It was a common practice in the 19th century, when mechanical enlargements and reductions were easily produced by an invention called the Collas machine. According to Luc-Benoist (p. 151), Barye was "one of the first to use the reduction machine. He had one in his studio." In Barye's last sales catalogue, the *Cerf bramant* (*Braying Stag*), no. 213, was offered with the dimensions 21 x 18 cm under the heading of "new models."

A bronze modèle and its plaster were sold at the Barye Hôtel Drouot sale of 1876, but no size is given. A bronze modèle belonging to Barbedienne is listed as no. 58 in the 1889 École des Beaux-Arts catalogue. A bronze cast with the dimensions 18 x 18 cm is no. 132 in the same catalogue and no. 250 is a bronze cast measuring 14 x 16 cm.

Bibliography: Quai des Célestins, 4, 1865, no. 213;
Paris, 1876, no. 653; Paris, 1884, no. 60; Paris, 1889,
nos. 58, 132, 250; New York, 1889, no. 70;
Barbedienne, 1893, p. 5; Luc-Benoist, 1928, p. 151;
Paris, 1956–1957, no. 49, pl. IX; Hubert, 1957, p. 154
(ill.); Benge, 1969, pp. 308–310, no. 85a, fig. 24;
Paris, March 1972, no. 17; Pivar, 1974, p. 180, A118;
Zoubaloff, n.d., p. 16, no. 1597.

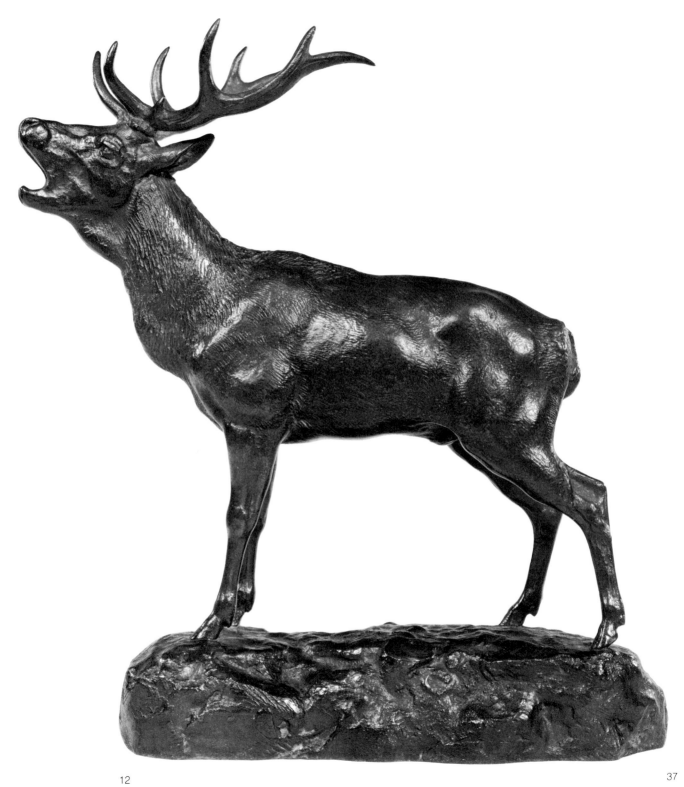

Deer

Wax with original wooden base, 16.8 x 19.9 cm
Markings:
Top of base, proper left rear corner: BARYE
Under side of base: circular paper label toward front
marked 140 in brown ink
Toward rear: rectangular pressure-sensitive label
marked 54 in blue ink
Grenville L. Winthrop Bequest, 1943.1086

The deer was formed in red wax over a metal
armature. The surface of the sculpture has been
coated with a shellaclike substance, giving it a dark
brown to black appearance.

Traces of plaster around the wooden base suggest
that the mounting was larger at one time. The
sculpture, however, shows no obvious evidence of
having been cast.

Allowing for certain alterations because of the fragility
and pliability of the wax, this deer lacks the grace and
elegance of other Barye animals of the deer family. It
is chunkier with a rigid, bony back and not as subtle
as his other deer and stags. It is less idealized, and
seems realistic to the point of appearing old and
bony. It was perhaps a sketch taken from life of a
particular animal, or even a modèle never used.

The wide snout is closest to the *Ganges Deer*
illustrated in Pivar p. 178.

Bibliography: London, 1972, p. 37 (ill.).

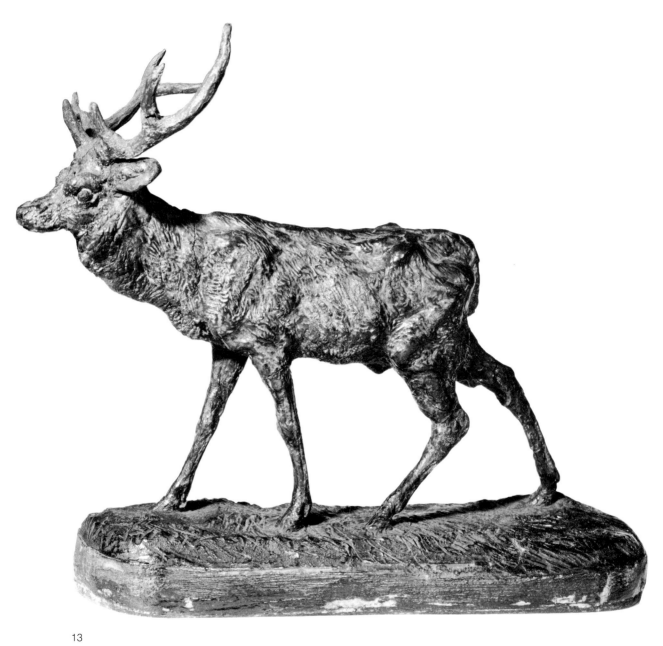

13

Lion Crushing a Serpent (Lion au serpent)

Bronze, 26.1 x 35.6 cm.
Markings:
Top of base, proper right rear: BARYE
Henry Dexter Sharpe Collection, 1956.167

This is an excellent cast in reduced size, with golden brown patina, of Barye's first famous work, which was shown life size (H. 1.38 m) in plaster at the Salon of 1833. A symbolic flattery of the July Monarchy, the sculpture won respect for animal sculpture and, for Barye, the patronage of the House of Orléans. The Minister of State purchased the plaster from the Salon, had it cast in bronze, and placed it in the Tuileries Garden.

The appearance of both the plaster at the salon of 1833 and the lost-wax bronze in the Tuileries in 1836 elicited a flurry of negative criticism as well as praise. Gerard Hubert, writing of Barye and the criticism of his time in *La revue des Arts* quotes the outcry of certain members of the Institute: "Do they take the Garden for a menagerie—let them put it back in its cage." But Ballu (p. 47) maintains that despite the negative reaction, the "current of admiration was stronger." He quotes Charles Lenormant's article on the Salon of 1833 in *Les Artistes Contemporains*: "I begrudge the sculptor the trouble he had taken to reproduce all the details of hide and fur. . . . But I soon noticed that I was stopped by these details. The more I looked at the *Combat of the Lion and Serpent* the more the impression grew; it seemed to me at first the lion moved; yesterday I heard it roar."

Alfred de Musset, in his Salon piece in the *Revue des Deux Mondes* described Barye's lion as "frightening as nature. What strength and what truth! The lion roars, the serpent hisses. What rage in this snarling mask, in this sideward glance, in this bristling back! What power in that paw pounced on its prey. . . . Where has Mr. Barye posed models such as these? Is his studio a desert of Africa or a forest in Hindustan?"

The famous image was offered to the public in several reduced sizes. The *Lion and Serpent* was offered as no. 36, H. 56 cm in the Barye Sales Catalogue, Rue des Fossés-Saint-Victor, 13. In the Catalogue Quai des Célestins, 10, *Lion au Serpent* is listed as no. 43, H. 12 cm, along with Reduction no. 1, H. 26 cm, and Reduction no. 2, H. 18 cm. In the last Barye sales catalogue (Quai des Célestins, 4), three sizes are offered as follows: no. 40, H. 14 cm; no. 41

(Reduction no. 1) H. 26 cm; no. 42 (Reduction no. 2) H. 18 cm; no. 43 (no. 3) "esquisse" (sketch) H. 15 cm. The Barye sale at the Hôtel Drouot in 1876 included no. 432, *Lion and Serpent* no. 2, no. 433, *Lion and Serpent* no. 3, both under the heading: "Bronzes cast from the plaster having served as model." It is also listed as no. 699, a bronze modèle with its plaster. Reduction no. 1 appears eight times in the 1889 École des Beaux-Arts catalogue.

The Fogg's cast is Reduction no. 1. There is a master bronze or modèle for Reduction no. 1 in the Walters Collection (no. 27.157). Fine-scratched mold marks on the Walters cast indicate that it was used for sand molding. Its slightly larger size and superior detail (including a minute foundry stamp with the letters VP under a crown) also indicate that it is a modèle.

A cast of *Lion and Serpent* in the Brooklyn Museum (no. 10.178) measures 25.7 x 35.5, approximately the dimensions of Reduction no. 1. It is sand cast in at least two parts and has a green over brown patina. The BARYE signature appears on top of the base, proper right rear.

A Barbedienne cast of the life-size *Lion and Serpent* was installed in 1893 in Rittenhouse Square, Philadelphia, by the Fairmont Park Association.

For an additional discussion of *Lion Crushing a Serpent* see Wasserman, 1975, pp. 89–104.

Bibliography: Guillaume, n.d., pp. 198, 200–203, 205–206, 221–222; Planche, 1855, pp. 48–51; Rue de Fossés-Saint-Victor, 13, 1855, no. 37; Quai des Célestins, 10, 1855, no. 44; Quai des Célestins, 4, 1865, no. 41; Mantz, 1867, pp. 114–115, 119; Paris, 1876, nos. 432, 433, 699; Paris, 1884, no. 10; Paris, 1886, no. 3; Alexandre, 1889, p. 13 (ill.); De Kay, 1889, pp. 2, 25, 26, 31–35, 61, 135, no. 24 (ill.); Paris, 1889, nos. 204, 264, 477, 520, 550, 558, 565, 604; New York, 1889, nos. 36, 137, 218, 287, 356; Ballu, 1890, pp. 47–52, p. 48 (ill.); Paris, 1891, no. 6; Smith, 1902, pp. 200–204, p. 203 (ill.); Masters in Art, vol. 5, 1904, pl. 10; Baltimore, 1911, no. 489; Paris, 1914, p. 84, no. 120 (ill.); Saunier, 1925, pp. 17–19, pl. 2; Washington, 1939, p. 117, no. 722; Metropolitan, 1940, fig. 13 (ill.); Hubert, 1956, pp. 225–226, 229, no. 2 (ill.); Paris, 1956–1957, no. 10; Lengyel, 1963, ill.; Baltimore, 1965, no. 381; San Antonio, 1965, no. 8; Benge, 1969, pp. 321–323, no. 134c, fig. 105; New York, 1971, no. 17 (ill.); London, 1972, no. 2 (ill.); Paris, June 1972, no. 27 (ill.); Paris, March 13, 1973, no. 24 (ill.); Mackay, 1973, p. 26; Pivar, 1974, p. 122, A37; Wasserman, 1975, pp. 77, 89–104, nos. 9–13, 18–29 (ills.); Los Angeles, 1980, pp. 124–125, 128–129.

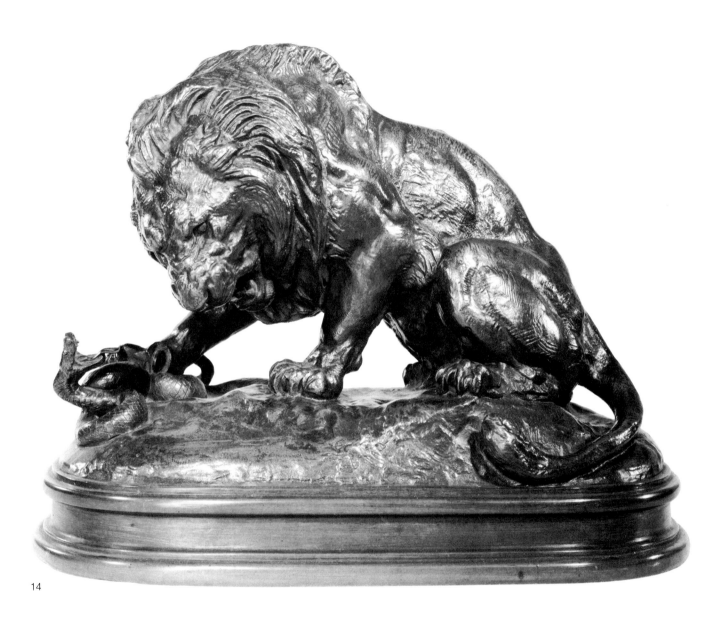

14

15
Eagle with Outspread Wings and Open Beak
(Aigle les ailes étendues, le bec ouvert)

Bronze, 25.1 x 24.7 cm
Markings:
Top of base, proper right front: A L BARYE
Grenville L. Winthrop Bequest, 1943.1127

Signed A L BARYE, this cast of an eagle was formerly
in the collection of Comte de Berthet and acquired by
Mr. Winthrop from Knoedler & Co., in 1912. It is sand
cast in two parts and its patina shows traces of green,
black, and brown. It has not been carefully chased,
particularly in the area of the wings.

Pivar illustrates a similar eagle on a rock with closed
beak in the Metropolitan Museum, New York, and an
open-beaked eagle surmounting a dead heron in the
Walters Art Gallery, Baltimore, where there is also a
cast of the Fogg version.

These eagle images, essentially the same subject
with outspread wings, were undoubtedly studies for a
government commission Barye received in 1835
(which was later cancelled) to create a 70-foot-wide
bronze eagle for the top of the Arc de Triomphe.

*Bibliography: Quai des Célestins, 10, 1855, no. 133;
Quai des Célestins, 4, 1865, no. 131; Paris, 1889, nos.
108, 168, 287, 332; New York, 1889, no. 331; De Kay
1889, pp. 59–60, no. 40 (ill.); Ballu, 1890, p. 64 (ill.);
Barbedienne, 1893, p. 6; Baltimore, 1911, nos. 425,
439; Baltimore, 1965, no. 360; Benge, 1969, pp.
359–360, no. 28b, fig. 205; New York, 1971, no. 34;
Pivar, 1974, p. 220, A169.*

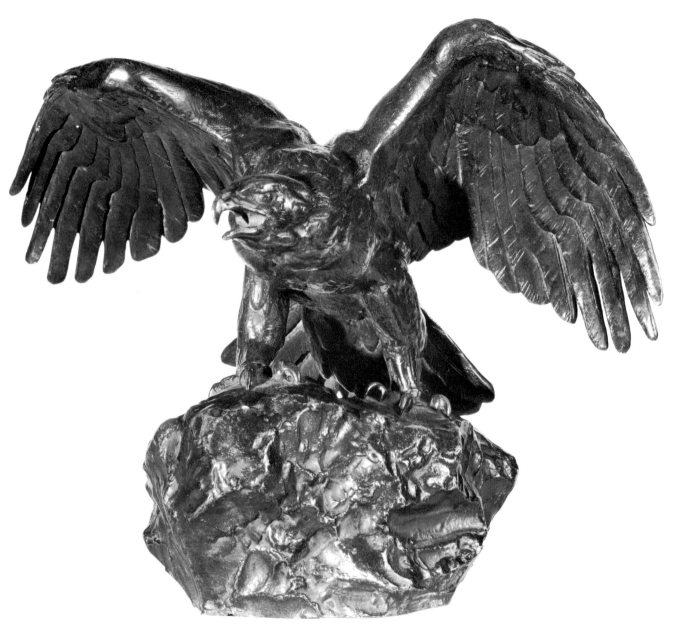

15

Walking Lion (Lion de la Colonne de Juillet?)

Bronze relief plaque, 19.3 x 39.7 cm
Markings:
Top of base, right side: BARYE
Henry Dexter Sharpe Collection, 1956.152

This relief plaque is sand cast, with a brown and green patina. It appears to be a variant of the so-called *Lion of the July Column*, which is to be found in many French and American Barye collections.

In the 1830s Barye received a commission for decorations of the pediment of the "Column of the Bastille," also known as the "July Column." It was designed for the Place de la Bastille as a monument to commemorate those who died in the July Revolution of 1830. Ballu (p. 84) recounts that the first stone was placed in 1831 and the monument was not dedicated until July 1840. Ballu also writes that Duc, the architect in charge of the monument, demanded of Barye several versions, in different proportions, of his lion in high relief.

The final composition shows the lion (which is the sign of the zodiac for the month of July), pacing against a background of stars and lines indicating the path of the zodiac. It is this composition most often reproduced in the Barye literature (i.e., Ballu, De Kay, Alexandre, etc.) and the reduction of this lion which appears in most collections. Charles Blanc, of the Académie des Beaux-Arts, described it as "the guardian of a monument which, it seems, he will always encircle. [He is] the image of the people guarding their dead."

Reduced versions of this zodiac lion were examined in the Walters and Corcoran Collections. They are both sand cast with a brown patina and measured 20.5 x 42.5 cm. They are comparable in quality—good, but not exceptional casts.

The Fogg's *Walking Lion* relief, possibly one of Barye's earlier versions for the column in reduced form, is a different animal. He looks straight ahead, his tail curves up, not down, and the position of his legs is reversed. He is a more robust lion than the zodiac version, recalling the *Walking Lion* in the round of the mid-30s (see fig. 29a).

A cast of the Fogg's version in the Brooklyn Museum (no. 10.189) measures 20.1 x 41 cm (slightly larger than the Fogg's) and has a red brown patina. It is probably a sand cast, although it is unusually thin. The quality of the cast is comparable to the Fogg's. Formerly in the Cyrus J. Lawrence Collection, the Barye Monument Association catalogue of 1889 lists this cast (no. 268) as "modern" or posthumous.

The Fogg's cast is illustrated by Pivar (no. R8, p. 244) and listed as no. 16 in the San Antonio exhibition catalogue, February 1965. Another cast of this version is illustrated (no. 47) in the Parke-Bernet sale of the Black-Nadeau Collection, 1971, with the measurements 9¼ x 19⅜" (23.5 x 49.2 cm), considerably larger than the Fogg's and Brooklyn's. Apparently few casts were made of this version.

The 1876 Barye sale of the Hôtel Drouot offered as no. 518 "Lion de la Colonne de Juillet, premier project," under plaster sketch. This could refer to the Fogg's version.

Bibliography: Paris, 1876, no. 518; New York, 1889, no. 268; San Antonio, 1965, no. 16; New York, 1971, no. 47 (ill.); Pivar, 1974, p. 244, R8.

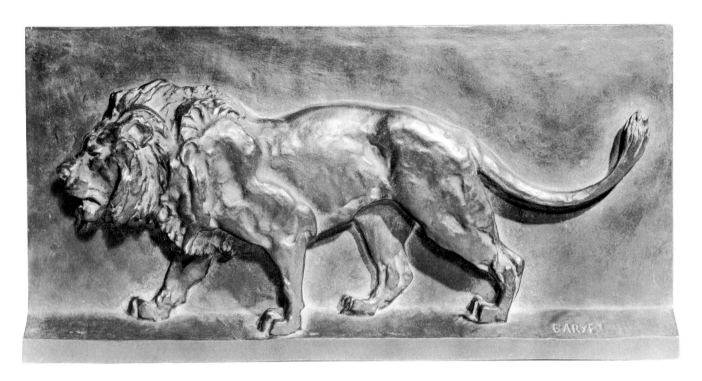

16

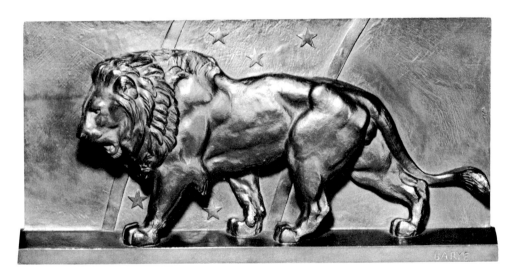

16a Walking Lion, relief (no. 27.165)
Walters Art Gallery, Baltimore

Half-Blood Horse (Cheval demi-sang)

Bronze, 14 x 17.7 cm
Markings:
Top of base, proper right rear: BARYE
Under base: HDS from SDK in black ink
Henry Dexter Sharpe Collection, 1956.161

This is a good serial sculpture, sand cast in one piece. The patina is an unusually bright green without a blending of other colors.

It is similar in quality to the Walters cast of the same subject (27.52), although the latter has a reddish brown patina. Both casts are close enough in measurements to be of the same edition. A cast of similar quality in the Brooklyn Museum also appears to be sand cast in one piece. Although the patina of the horse is a reddish brown comparable to the Walters cast, the Brooklyn cast's base is patinated green. The drastically different colors of the patinas illustrate the kinds of changes made from cast to cast in the larger 19th-century bronze editions.

This is particularly true of the Barye editions, for Barye was deeply involved in experimenting with different colors in his patinas. Arsène Alexandre wrote (on p. 91) that he was incapable of achieving the same patina twice. ". . . he applied particular care to the patina, in quest of all that could give the bronze a brilliant, warm and delicate surface." In his preface to the Sichel sales catalogue Edmond de Goncourt wrote: "His patinas so diverse and varied, arose with time and rubbing above the greyish green [color] rather compact, a bit uniform, which the foundry had adopted." De Goncourt describes Barye's various patinas as having "the green of the sea, a Florentine nuance, a blackish color like that of old medals, and above all a brown patina through which the animal is penetrated by russet red."

The Half-Blood Horse is found in all six of the Barye sales catalogues, and in the last three it is listed as a pair with the reduction of the *Half-Blood Horse with Head Lowered* (nos. 95 and 96). The Barye sale of 1876 at the Hôtel Drouot lists no. 701 *Cheval demi-sang* as a bronze modèle with its plaster and no. 702 as *Petit cheval demi-sang*, which is presumably also a bronze modèle. Barbedienne, in fact, exhibited a bronze modèle of *Petit cheval demi-sang* (no. 41) in the 1889 École des Beaux-Arts exhibition. Four additional bronze casts were exhibited there from other collections. They are designated in the catalogue as reductions, with dimensions close to the Fogg's. Five casts were exhibited from as many collections in the exhibition catalogue of the Barye Monument Association of 1889.

Bibliography: 12, Rue Chaptal, n.d., no. 22 or 23; Rue Saint-Anastase, 10, n.d., no. 22 or 23; Rue de Boulogne, No. 6, 1847–1848, no. 22 or 23; Rue de Fossés-Saint-Victor, 13, 1855, no. 78; Quai des Célestins, 10, 1855, no. 98; Quai des Célestins, 4, 1865, no. 96; Paris, 1876, nos. 701, 702; Paris, 1886, no. 20; Paris, 1889, nos. 41, 159, 275, 359, 364; New York, 1889, nos. 105, 341, 368, 387, 439; Barbedienne, 1893, p. 5; Paris, 1956–1957, no. 66; Benge, 1969, pp. 349–351, no. 41b, fig. 194; London, 1972, no. 12 (ill.); Pivar, 1974, p. 204, A148.

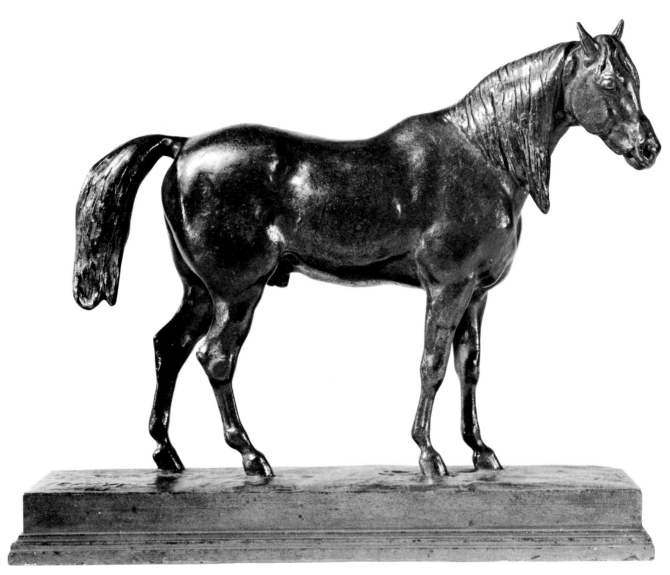

17

Walking Tiger (Tigre marchant)

Bronze, 21.4 x 42.3 cm
Markings:
Proper right rear top of base: BARYE
Proper left rear top of base: F. BARBEDIENNE,
Fondeur
Center underside of base: 43 (incised)
Proper right underside of base: in black ink 9961
Sin
P
p (incised)
Gift of Mrs. Robert H. Monks, 1927.97

This is a Barbedienne cast of good quality. Although the subject was exhibited by Barye in the Salon of 1836, it was very popular, and could have been cast posthumously when Barbedienne acquired 125 Barye models at the Drouot sale in 1876, after Barye's death.

Sand cast in two parts with a green over brown patina, this cast compares favorably with one in the Walters Art Gallery, which has the same dimensions, but a brown patina. A cast in the Corcoran Gallery has a black-green patina, but the tiger's stripes are not as distinctly articulated as they are on the Fogg cast. A cast in the Metropolitan Museum has a brown patina, and a different base composed of high craggy rocks instead of the flat smooth base with a pattern of stepping stones, like the others.

The cast in the Brooklyn Museum (no. 10.208) measures 21.3 x 41.5, almost a centimeter shorter in length than the Fogg and Walters casts. Besides the BARYE signature on the top of the base, proper right rear, the Brooklyn cast has incised on the top of the base, proper left rear "DEP ce DELESALLE." Inked numbers inside the base could not be deciphered. The Brooklyn cast compares in quality with the others described above, and is a thin cast made in two parts. The patina is brown with touches of green.

This subject, entitled *Tigre qui marche* (no. 46), appears bracketed with *Lion qui marche* (no. 45) with the word "pendants," (counterparts or matching pair) in the Barye sales catalogue of Rue de Fossés-Saint-Victor, 13, and in the Catalogue of Quai des Célestins, 10 (where they are numbered 54 and 53 respectively). In three previous Barye sales catalogues and the last, they appear separately rather than as pairs. In the 1876 Barye sale at the Hôtel Drouot, bronze modèles of *Tigre qui marche* no. 1 and 2 were offered. A

bronze modèle belonging to Barbedienne is listed as no. 21 in the 1889 catalogue of the École des Beaux-Arts. It also includes a bronze cast belonging to Mr. Lucas (no. 148) with the measurements 21 x 40 cm and no. 268, a bronze cast loaned anonymously with the measurements 22 x 40 cm.

Bibliography: 12, Rue Chaptal, n.d., no. 49; Rue Saint-Anastase, 10, n.d., no. 49; Rue de Boulogne, No. 6, 1847–1848, no. 49; Rue de Fossés-Saint-Victor, 13, 1855, no. 46; Quai des Célestins, 10, 1855, no. 54; Quai des Célestins, 4, 1865, nos. 52, 219; Paris, 1876, nos. 599, 657; Paris, 1884, no. 15; Paris, 1886, no. 6; Paris, 1889, nos. 21, 148, 268; De Kay 1889, p. 10, no. 3 (ill.); New York, 1889, nos. 45, 142, 221, 291, 328, 380, 395, 408, 425, 428, 448; Ballu, 1890, pp. 132–133, p. 132 (ill.); Paris, 1891, no. 9; Barbedienne, 1893, p. 3; Baltimore, 1911, nos. 422, 570; Paris, 1914, p. 78, no. 102; Saunier, 1925, p. 25; Washington, 1939, p. 118, no. 727; Metropolitan, 1940, fig. 20; Paris, 1956–1957, no. 32; Baltimore, 1965, nos. 405, 406; San Antonio, 1965, no. 10; Benge, 1969, pp. 337–339, no. 104e, fig. 173; New York, 1971, no. 38; London, 1972, no. 36; Paris, March 13, 1973, no. 10; Pivar, 1974, p. 141, A58.

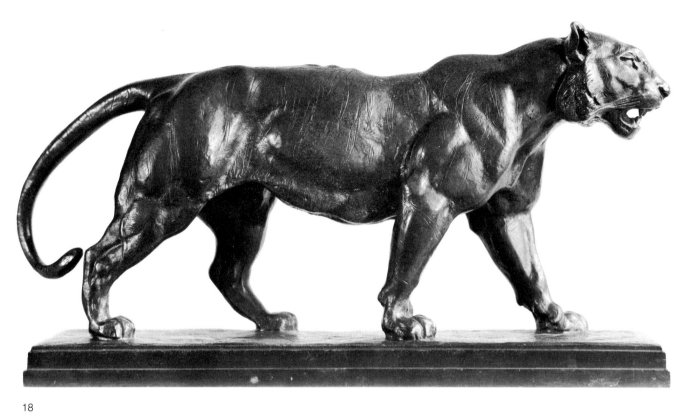

18

A Jaguar Devouring a Hare (Jaguar devorant un lièvre)

Bronze, 14 x 33.3 cm
Markings:
Top of base, proper left rear: L BARYE
Grenville L. Winthrop Bequest, 1943.1395

This sculpture in plaster was one of the pieces with which Barye reentered the salon in 1850 after an absence of fourteen years. In his introduction to the Sichel catalogue, Edmond de Goncourt described this sculpture as "a perfect rendering of the gluttonous, voluptuous enjoyment of the feline beast in the taste of blood." In 1855 Barye entered it along with other bronzes in the industrial section of the Exposition Universelle where he won the Grand Medal of Honor.

The Fogg's reduction of the salon subject is an unusually heavy sand cast made in two pieces with a dark brown patina. Although Barye's *Jaguar* is a sleek, almost abstractly smooth animal, this reduction is notably lacking in detail, particularly in the modeling of the hare. It could not be directly compared to the cast in the Walters Art Gallery (no. 27.180), which is much larger, approximately the size of the original salon entry (42 x 104 cm). The Jaguar of the Walters piece, however, has good surface detail and there is excellent detail on the front of the hare. It has a green and black patina.

Jaguar devorant un lièvre first appears in the third Barye sales catalogue, Rue de Fossés-Saint-Victor with the dimensions 44 x 105 cm, and the notation that a cast is in the Musée de Luxembourg. It appears with the same dimensions in the following and last two catalogues (Quai des Célestins, 10, 4). The bronze model with its plaster is no. 725 in the 1876 Barye sale at the Hôtel Drouot. In the 1889 catalogue of the École des Beaux-Arts, no. 6 is a bronze modèle belonging to Barbedienne and no. 246 is a cast which belonged to Bonnat, with the measurements 46 x 30 cm.

The Barye Monument Association catalogue of 1889 lists Walters' cast as 15½ x 38" (39.3 x 97 cm) and a cast belonging to Charles A. Dana as 17½ x 38" (44.5 x 97 cm). In the Louvre exhibition catalogue of 1956–1957, a bronze modèle is listed with the dimensions 42 x 95 cm and the notation that the plaster model shown at the Salon of 1850 also belongs to the Louvre. A further note states that the bronze had been ordered by the state in 1851 and appeared at the Salon of 1852. It was preserved as a modèle by Barye, and then belonged to Goupil, Barbedienne, and Zoubaloff who gave it to the Louvre in 1912.

Barbedienne casts appear in two Palais Galliera sales catalogues on March 13, and March 19, 1973 with measurements of 17.5 x 41 cm and 41 x 91 cm respectively. A cast borrowed from the William Rockhill Nelson Gallery appears in the Marion Koogler McNay Art Institute exhibition catalogue of February 1965 with the dimensions 16 x 40" (40.7 x 104 cm). A cast (no. 121) with dark green patina, in the Christie's East sale of March 16, 1982 is closest to the Fogg's length, measuring 15½" long or 39.4 cm.

Since, so far, no cast with the exact dimensions of the Fogg's reduction has been found, a detailed comparison of the Fogg cast cannot be undertaken at this time, and the model from which it was made remains a mystery. The poor quality of the cast and its lack of detail would indicate a surmoulage. Furthermore, the atypical signature "L BARYE" could be the result of poor reproduction in which the "A" was lost, or could be a spurious cast by Barye's son, Alfred.

Bibliography: Guillaume, n.d., pp. 242–243; Rue de Fossés-Saint-Victor, 13, 1855, no. 65; Quai des Célestins, 10, 1855, no. 78; Quai des Célestins, 4, 1865, no. 76; Mantz, 1867, pp. 121–123; Paris, 1876, no. 725; Paris, 1886, no. 1; Paris, 1889, nos. 6, 246; New York, 1889, nos. 7, 406; Alexandre, 1889, pp. 55–56, p. 17 (ill.); De Kay, 1889, pp. 89–90, no. 59 (ill.); Ballu, 1890, pp. 104–106, 109, p. 106 (ill.); Barbedienne, 1893, p. 4; Smith, 1902, p. 220 (ill.); Masters in Art, vol. 5, 1904, p. 9; Paris, 1914, p. 83, no. 116 (ill.); Saunier, 1925, pp. 35–36, pl. 14; Washington, 1939, p. 121, no. 798; Hubert, 1956, p. 227, no. 4 (ill.); Paris, 1956–1957, no. 4; Hubert, 1957, p. 157; San Antonio, 1965, no. 54 (ill.); Benge, 1969, pp. 362–363, no. 128, fig. 214; New York, 1971, no. 59 (ill.); London, 1972, no. 10 (ill.); Paris, March 1972, no. 50; Paris, March 13, 1973, no. 2 (ill.); Paris, March 19, 1973, no. J (ill.); Mackay, 1973, p. 36; Pivar, 1974, p. 154, A82; Benge, 1974, p. 34, fig. 2; Wasserman, 1975, p. 78; Los Angeles, 1980, p. 125; New York, 1982, p. 124, fig. 121 (ill.); Zoubaloff, n.d., p. 14, no. 1565, p. 17, no. 1553.

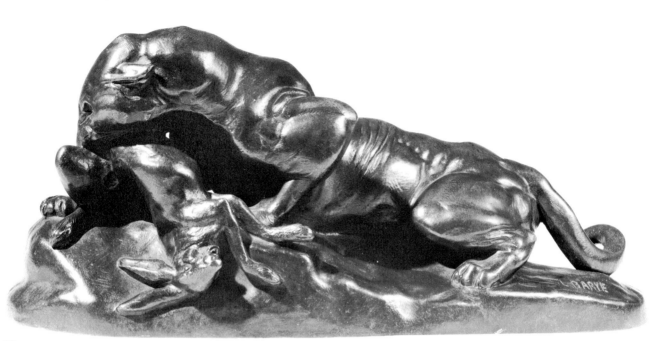

19

Turkish Horse, Right Foot Raised (Cheval turc)

Bronze, 25.4 x 29.6 cm
Markings:
Top of base, center rear: BARYE
Henry Dexter Sharpe Collection, 1956.165

Sand cast in two parts, the Fogg horse has a brown-black patina. Both cast and patina are poor quality. The base is unusually shallow as if it were but one section of a multi-stage base. There is a great deal of arbitrary chasing on the back of the tail and top of the mane.

The cast of this subject in the Walters Art gallery (no. 27.67) is superb, sand cast in two parts, with dark brown patina. The reproduction of detail is so perfect that finger prints are discernible on a built-up waxlike mound on the top of the base and under a former wax pellet with the stamped number 029. Other markings inside the base are stamped number 29 and, written in ink: "M^r· Lucas."

Furthermore, the Walters cast has a subtle modeling of the horse's body which is not apparent on the Fogg cast. The horse's chin touches his neck on both casts, but the Walters' base is rectangular, the Fogg's oval. Cut lines or scratches on the base of the Walters cast, made by sand molds, suggest that it was used as a modèle.

Comparative measurements show that the Fogg cast is an average of from one to two percent smaller, or once removed from the Walters'. It is, therefore, probably not an unauthorized surmoulage, but perhaps a poor cast from another edition.

The Corcoran's *Turkish Horse* (no. 73.71) is on a higher base than the Fogg's or Walters'. It is a two-stage double base which rises higher in front and has a rougher articulation than the others. Also the BARYE signature is placed on the proper left center of the top of the base rather than the center rear as on the Fogg's and Walters' casts. It has been cast in two parts, but the base is lost-wax, rather than sand cast, like most Barye sculptures. The Corcoran horse has less detail than the Walters' and slightly less than the Fogg's. It appears generally softer. The patina is black with green and the horse's chin does not touch its neck as in the Fogg's and Walters' casts.

The *Turkish Horse* in the Brooklyn Museum (no. 10.163) measures 28.6 x 20.9 cm. Like the Corcoran's cast, the base is higher in front than the Fogg's or Walters', with rougher articulation of the surface. It is a two-stage double base, and this accounts for the larger height dimension than the Fogg's. The base is a lost-wax cast like the Corcoran's and is different from the Fogg's. Although the cast is of poorer quality with less detail than the Fogg's, it is interesting to note that the horse's chin does not touch its neck, like the Walters' cast and the Fogg's.

According to the catalogue of the Barye Monument Association exhibition of 1889, there are two versions of the *Turkish Horse*, one with "Right foot raised" (no. 160) and one with "Left foot raised" (no. 161). Both versions are listed in the section devoted to the Corcoran Collection (see nos. 20c and 20d).

Photographs in the Barye literature show that several variations of *Cheval turc* exist within both the "Left leg raised" and "Right leg raised" versions. In both versions there are casts with oval and rectangular bases and there are casts with the horse's chin touching his neck and others with the horse's chin entirely separated from the neck. In all six Barye sales catalogues *Cheval Turc* and *Autre Cheval Turc* are listed as "pendants" or pairs with dimensions of 30 x 26 cm.

In the 1876 Barye sale at the Hôtel Drouot, no. 658 is listed as "Cheval turc no. 1. Modèle in bronze with its plaster." Item no. 703 describes "a lot including a Cheval turc no. 1, ditto no. 2, ditto no. 3." All are modèles in bronze with their plasters. Item no. 704 lists only the bronze modèle for *Cheval turc*. Since no dimensions are given, the differences between these horses is unclear. In the 1889 catalogue of the École des Beaux-Arts there are three bronze modèles (nos. 38, 39, 40) of *Cheval turc* belonging to Barbedienne and five bronze casts from other collections. They include versions with both right and left leg raised, and the dimensions vary.

Bibliography: 12, Rue Chaptal, n.d., nos. 52, 53; Rue Saint-Anastase, 10, n.d., nos. 52, 53; Rue de Boulogne, No. 6, 1847–1848, nos. 52, 53; Rue de Fossés-Saint-Victor, 13, 1855, nos. 79, 80; Quai des Célestins, 10, 1855, nos. 99, 100; Quai des Célestins, 4, 1865, nos. 97, 98; Paris, 1876, nos. 703, 704; Paris, 1884, nos. 53, 54; Paris, 1886, nos. 7, 8; Paris, 1889, nos. 38, 39, 40, 104, 125, 160, 161, 224, 276, 277, 431; New York, 1889, nos. 102, 160, 161, 226, 297, 298, 332; Alexandre, 1889, p. 65 (ill.); Ballu, 1890, no. 84 (ill.); Paris, 1891, no. 10; Barbedienne, 1893, p. 5; Baltimore, 1911, nos. 566, 569; Washington, 1939, p. 118, nos. 745, 746; Baltimore, 1965, nos. 368, 369; San Antonio, 1965, nos. 34, 35 (ill.); Benge, 1969, pp.

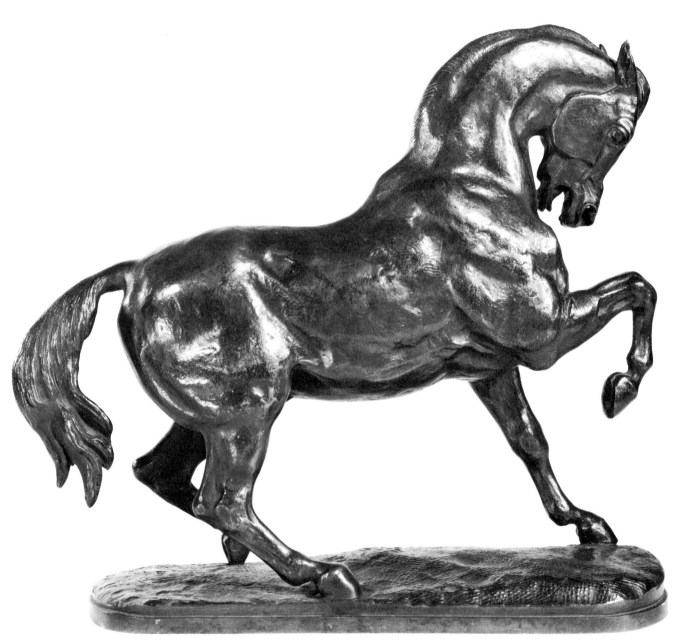

20

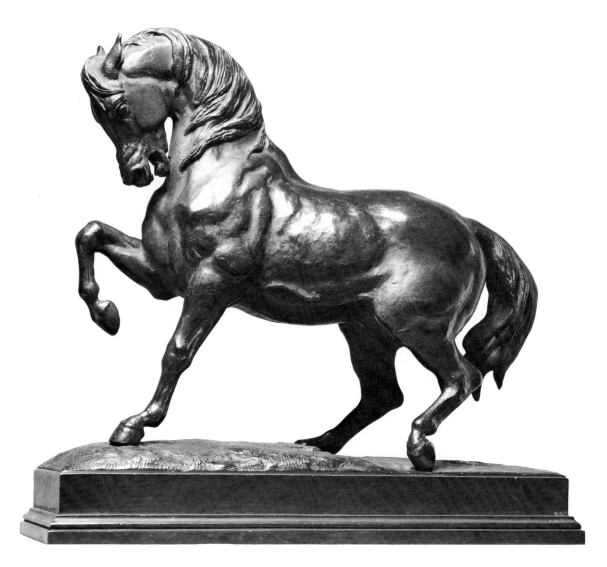

20a Horse with Raised Forefoot (no. 27.67)
Walters Art Gallery, Baltimore

Bibliography, continued

342–344, no. 44d, fig. 180, no. 44g; New York, 1971, no. 46; London, 1972, no. 34, p. 37 (ills.); Paris, June 1972, no. 28; Paris, March 19, 1973, no. E; New York, 1973, no. 17 (ill.); Mackay, 1973, p. 48 facing (ill.); Pivar, 1974, p. 205, A149, p. 206, A150; Zoubaloff, n.d., p. 17, no. 6726, p. 40, no. 1053.

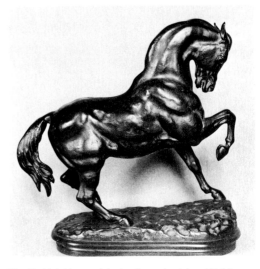

20c Turkish Horse, right foreleg raised (no. 73.71)
In the Collection of the Corcoran Gallery of Art, Washington, D.C.

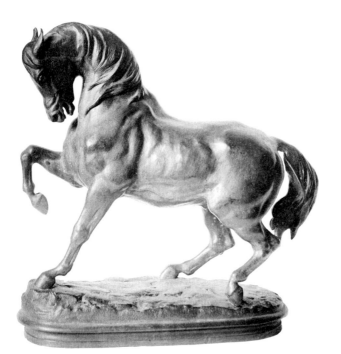

20b Turkish Horse (no. 10.163)
The Brooklyn Museum, Purchased by Friends of the Museum by Special Subscription

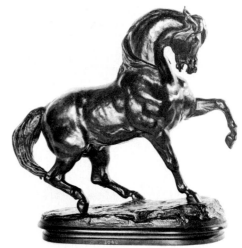

20d Turkish Horse, left foreleg raised (no. 73.72)
In the Collection of the Corcoran Gallery of Art, Washington, D.C.

Reclining Panther (Une Panthère couchée)

Bronze, 6.7 x 18.7 cm
Markings:
Top of base, proper right front: BARYE
Underneath base, left side: three stickers as follows:
"From H. Burlingham 1928"; Soden Smith Collection
Edinborough Museum 1911; From _____ House
Grenville L. Winthrop Bequest, 1943.1284

Sand cast in one piece, with a brown patina, this is a typical example of a 19th-century edited cast.

A cast of the same subject in the Corcoran Gallery Collection (no. 74.28) measures 7 x 18.7 cm. It is similar to the Fogg's in quality and has the same base profile. The patina, however, is dark green.

Another cast in the Brooklyn Museum (no. 10.158) was examined and found to have similar measurements (6.9 x 18.7 cm) and the BARYE signature on top of the base, proper right front. It also is a sand cast with traces of green on its brown patina. The detail is comparable to the Fogg's cast.

Une Panthère couchée with the dimensions 7 x 18 cm, is listed in all six Barye sales catalogues. The similarity of size to the Fogg, Corcoran, and Brooklyn panthers suggests that it is the same sculpture.

A bronze *modèle* of *Panthère couchée* is no. 589 in the 1876 Barye sale at the Hôtel Drouot. In the 1889 École des Beaux-Arts catalogue, no. 19 is a bronze *modèle* belonging to Barbedienne and there are, in addition, four bronze casts listed with dimensions similar to the Fogg's.

The Fogg's *Reclining Panther* is illustrated in Pivar as A72, p. 149, with the title *Panther of India* (13 x 25 cm) and Benge lists it (p. 435, no. 68e) under the heading *Panther of India, Reduction, un panthère couché (sic), panthère de l'Inde, reduction* with the dimensions 7 x 18", 10 x 20 cm. His fig. 75, from the Lucas Collection in the Baltimore Museum of Art, is the same panther as the Fogg's.

Like the Barye elephants, rabbits, deer, and other groups of similar animals, titles have become confused in the voluminous Barye literature. Unfortunately Barye's own sales catalogues are not illustrated and identification often depends on their somewhat inaccurate published measurements. It would seem, however, that this small *Reclining Panther* is not, as it is often labeled, a reduction, but was always cast in this size.

Bibliography: 12, Rue Chaptal, n.d., no. 11; Rue Saint-Anastase, 10, n.d., no. 11; Rue de Boulogne, no. 6, 1847–1848, no. 11; Rue de Fossés-Saint-Victor, 13, no. 56; Quai des Célestins, 10, 1855, no. 66; Quai des Célestins, 4, 1865, no. 64; Paris, 1876, no. 589; Paris, 1889, nos. 19, 150, 360, 413, 460; New York, 1889, nos. 26, 434; Paris, 1891, no. 19; Barbedienne, 1893, p. 4; Baltimore, 1911, no. 436; Paris, 1914, p. 77, no. 101 (ill.); Baltimore, 1965, no. 392; Benge, 1969, pp. 317–318, no. 68e, fig. 76; New York, 1971, no. 23 (ill.); Pivar, 1974, p. 149, A72.

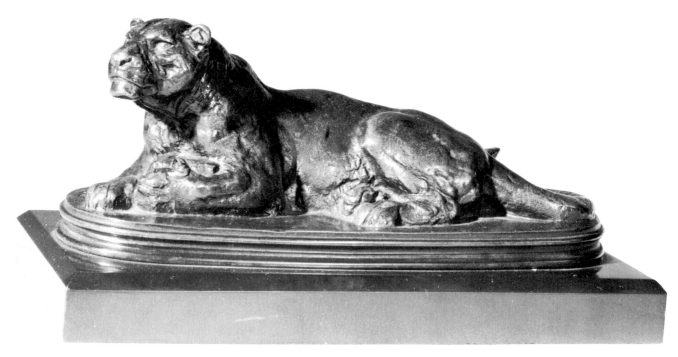

21

Reclining Panther Holding a Muntjac Deer
(Panthère couchée tenant un cerf muntjac)

Bronze, 10.2 x 21.3 cm
Markings:
Side of base, proper left rear: BARYE
Henry Dexter Sharpe Collection, 1956.160

This is a sand cast with dark green patina. The
BARYE signature has been reinforced. The inside of
the base has been filled with plaster, probably so that
a velvet covering could be applied.

The subject is first listed in the last Barye sales cata-
logue (Quai des Célestins, 4) as no. 223 *Panthère
couchée tenant un cerf muntjac* with the dimensions
11 x 21 cm. The bronze modèle with its plaster were
sold at the 1876 Hôtel Drouot sale as no. 654. Two
bronze casts with the dimensions 11 x 21 cm are
listed in the 1889 exhibition catalogue of the École
des Beaux-Arts. The plaster and wax original model is
listed as no. 17 in the 1956–1957 catalogue of the
Barye exhibition at the Louvre. On page 24 of this
catalogue the history of the "modèle original" traces it
to the Vente Barye, acquired by Delafontaine, a
founder, who gave it to the Musée des Arts decoratifs
in 1905. The dimensions, 10 x 22 cm, are given.

A bronze cast of this subject appears in the 1911
catalogue of the Lucas Collection exhibition at the
Maryland Institute as "*Panther with Paw on Muntjac
Deer* (1839) (Modern) Height 4 inches; length, 8¼
inches (10.1 x 21 cm). Dark golden brown patina."
(The term "modern" means a posthumous cast,
according to an explanation on p. 61 of the
catalogue.)

Panther Holding a Deer, 4 x 8½" appears among the
Cyrus Lawrence loans to the Barye Monument Asso-
ciation catalogue of 1889 (no. 239). An examination of
the Lawrence cast, now in the Brooklyn Museum (no.
10.159), revealed the dimensions 10.1 x 21.8 cm, or
slightly larger than the Fogg's. The BARYE signature
appears in the same place as on the Fogg's, but the
patina is green over red-brown rather than a solid
dark green. The sculpture was sand cast in several
sections with a surface texture comparable to the
Fogg's.

Both the Fogg and Brooklyn casts appear to be good
examples of 19th century casting in a large edition,
although there is no indication that they came from
the same edition. Their dimensions indicate that they
are once removed from the Louvre's "original model."

Benge lists the Fogg's cast as 143b following *Panther
and Deer* in the Walters Collection with the measure-
ments 3¾ x 8¾" (9.5 x 22.2 cm). His figure 167,
however, with its vertical silhouette, cannot possibly
be the Fogg's recumbent panther.

*Bibliography: Quai des Célestins, 4, 1865, no. 223;
Paris, 1876, no. 654; Paris, 1889, nos. 453, 569bis;
New York, 1889, no. 239; Baltimore, 1911, no. 426;
Paris, 1956–1957, no. 17; Baltimore, 1965, no. 394;
Benge, 1969, pp. 336–337, no. 143b, fig. 167; Pivar,
1974, p. 151, A75.*

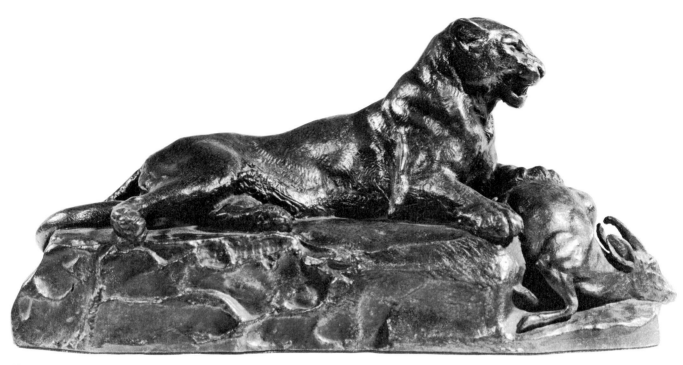

22

African Elephant (Éléphant d'Afrique)

Bronze, 13.3 x 19.5 cm
Markings:
Top of base, proper left front: BARYE
Henry Dexter Sharpe Collection, 1956.142

The *African Elephant* was probably sand cast in two parts. The base of this elephant, as in most Barye sculptures, has been cast separately. The patina is greenish black, and the cast has fairly good detail. The Fogg's *African Elephant* is illustrated in Pivar (no. A89, p. 158) and of the three elephants in the Fogg's Barye Collection it is the most stationary, hence the Fogg's descriptive title, *Standing African Elephant.*

The Corcoran's *African Elephant* (no. 73.68) is comparable in quality to the Fogg's with good, if not sparkling, detail. It is sand cast in two parts and has a black patina.

The *African Elephant* in the Brooklyn Museum (no. 10.149) has the same measurements as the Fogg's and the Corcoran's casts, is sand cast with red-brown patina and shows the same cold-working on the trunk. The BARYE signature, in the same place as on the other casts, is not incised but is carried from the wax model.

Barye's last sales catalogue (Quai des Célestins, 4) lists *Elephant of Asia*, no. 90, 14 x 16 cm, and its pendant *Elephant of Africa*, no. 91, with the same dimensions. Under "new models" this catalogue lists no. 211, *Elephant of Senegal*, 14 x 19 cm, and its pendant no. 212, *Elephant of Cochin China*, with the same dimensions. A bronze modèle of the *Éléphant d'Afrique* was offered in the Barye Hôtel Drouot sale of 1876. A bronze cast from the Bonnat Collection is listed as no. 242 in the 1889 École des Beaux-Arts catalogue. An original bronze modèle (13 x 16 cm) and a plaster modèle (14.5 x 16 cm) are nos. 60 and 61 in the catalogue of the 1932 George Haviland sale. Both are illustrated on plate XVII, and are, indeed, like the Fogg's *African Elephant.*

According to Pivar's illustrations the *Asian Elephant* (A88, p. 157, Walters) is moving in a fast trot with tail straight out behind him, the *African Elephant* (A89, p. 158, Fogg) is standing still, the *Elephant of Cochin China* (A91, p. 160, Walters, see Fogg no. III) is slowly walking with his proper right front leg bent. The *Elephant of Senegal* (A90, p. 159) is the running elephant, with ears laid back and only two feet touching the ground (see no. 24).

Bibliography: Quai des Célestins, 4, 1865, no. 91; Paris, 1876, no. 681; Paris, 1889, no. 242; New York, 1889, nos. 157, 422; Baltimore, 1911, no. 564; Paris, 1932, nos. 60, 61, pl. xvii; Washington, 1939, p. 118 (ill.); Pivar, 1974, p. 158, A89.

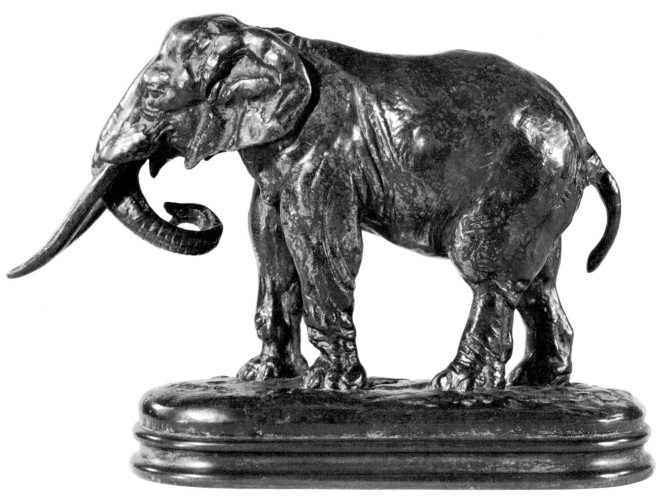

23

Elephant of Senegal (Éléphant du Sénégal)

Bronze, 13.8 x 20.3 cm
Markings:
Side of base, proper right center: BARYE
Henry Dexter Sharpe Collection, 1956.141

Sand cast in two pieces, this sculpture has a black patina with green highlights. The detail is good, and this appears to be a typical edition cast of one of Barye's popular subjects.

A cast in the Walters Art Gallery (no. 27.55) is by the Barbedienne foundry with the founder's name on the side of the base and a gold square, initialed F. B., inset toward the rear of the base. The patina is a golden brown. It is a sand cast of excellent quality, made in two parts. Comparative measurements show that the Fogg cast is slightly smaller and therefore probably once removed from the Walters Barbedienne cast, which might be a modèle.

The Brooklyn Museum has two casts of this elephant; one bronze and the other cast aluminum. The bronze cast measures 13.9 x 20.6 cm, close to the Fogg's. Like the Fogg's, it has no foundry mark, but does have the BARYE signature located on the side of the base, proper right center. The patina is red-brown and there are signs of cold-working on the trunk. It is a good sand cast, comparable to the Fogg's in quality.

The Brooklyn's aluminum cast measures 13.6 cm in height, but the length could not be measured because the tail has been broken off. The foundry mark "BARBEDIENNE Fondeur" is incised on the rear edge of the base. The patina is a greenish silver. The overall measurements of this cast are close to those of the bronze casts in the Fogg, Walters, and Brooklyn Museums and the details are fairly good.

Letters of 21 September 1900 and 26 April 1901 from George Lucas to Cyrus Lawrence, now in the Brooklyn Museum files, mention an exposition at which "an important house of works in aluminum" exposed works of Barye, including the *Elephant of Senegal*. The models belonged to Barbedienne, who made a special arrangement for "these proofs in aluminum."

Lucas also wrote that Barbedienne informed him that it was a metal "very different from bronze in the casting—it 'missing fire' often," and that aluminum casting was "entirely out of Barye's mind—so in ordering yours, ordered a small specimen for my collection."

This running elephant is an animated sculpture with curved trunk, and flying ears and tail. It is illustrated in most of the Barye literature from Ballu (1890) to Pivar (1974). It is listed as no. 211 under "nouveaux modèles" in Barye's last catalogue (Quai des Célestins, 4), and also in the Barbedienne catalogue of 1893, where it is offered in two sizes, 14 x 19 cm and a reduction, 7 x 9 cm. It is listed as no. 1, a bronze modèle belonging to Barbedienne, in the 1889 École des Beaux-Arts catalogue. Two bronze casts are also listed (nos. 368, 458) with the dimensions 14 x 19 cm. In the catalogue of the 1932 George Haviland sale, an "original modèle in plaster retouched with wax" is offered as no. 59 with the dimensions 15 x 20 cm. The catalogue notes that this modèle was no. 676 in the 1876 Barye sale, belonged to Barbedienne and appeared in the 1927 Zoubaloff sale.

Bibliography: Quai des Célestins, 4, 1865, no. 211; Paris, 1876, no. 676; Alexandre, 1889, p. 89 (ill.); De Kay, 1889, nos. 21, 86 (ill.); Paris, 1889, nos. 1, 368, 458; New York, 1889, no. 22; Ballu, 1890, p. 46 (ill.); Barbedienne, 1893, p. 5; Baltimore, 1911, no. 585; Masters In Art, vol. 5, 1904, pl. 2; Saunier, 1924, pl. 23; Paris, 1932, no. 59, pl. 16; Metropolitan, 1940, fig. 15; Paris, 1956–1957, no. 38; Hubert, 1957, p. 155 (ill.); San Antonio, 1965, no. 26; Benge, 1969, pp. 337–339, no. 29e, fig. 175; New York, 1971, no. 22; London, 1972, no. 76; Mackay, 1973, p. 48 (ill.); Pivar, 1974, p. 159, A90.

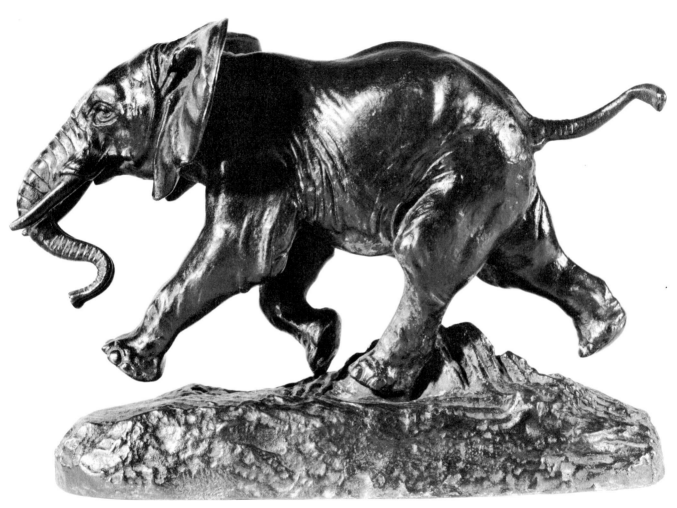

24

Dromedary of Algeria (Dromadaire d'Algérie)

Bronze, 19.7 x 25.1 cm
Markings:
Top of base, proper left center: BARYE
Henry Dexter Sharpe Collection, 1956.151

Sand cast in one piece, the dromedary has a reddish brown and green patina.

Barye's last sales catalogue (Quai des Célestins, 4) lists *Dromedary of Algeria* as no. 101 with the dimensions 19 x 18 cm and the *Reduction* as no. 102, 15 x 14 cm. Under "nouveaux modèles," the Barye catalogue lists no. 228, *Harnessed Dromedary of Egypt*, with the dimensions 24 x 19 cm, or the largest of the three camels.

In the 1876 Hôtel Drouot sale of the works of the "deceased Barye," no. 696 is described as "a lot including a *Dromedary of Algeria* no. 1 and ditto no. 2. Models in bronze with their plasters." In the École des Beaux-Arts exhibition catalogue of 1889 three bronze casts are listed with the dimensions of 19 or 20 x 18 cm.

Benge lists both camels harnessed and unharnessed as *Dromedary of Egypt Harnessed*, no. 26, p. 401.

According to the dimensions given in the Barye sales catalogue, the Fogg's *Dromedary of Algeria* is approximately the original size, whereas a cast in the Walters Art Gallery (no. 27.102) is the reduction. The Walters cast, however, is superb, with intricate surface detail which does not appear on the Fogg cast.

The reduced version of the Algerian Dromedary is listed in five collections in the exhibition of the Barye Monument Association of 1889, including the Walters' which is listed as "75 *Dromedary of Algeria*. Reduction 5½ x 6¾″ (14 x 17.2 cm)."

By great good fortune the Brooklyn Museum has the *Dromedary of Algeria* in both its original size (no. 10.148, 19.5 x 25.4 cm) and in its reduced size (no. 10.147, 15.1 x 18.6 cm). The larger camel lacks detail, particularly in the surface modeling, and is comparable in quality to the Fogg's. The BARYE marking, like the Fogg's, is on the top of the base, proper left center. The patina, however, is dark brown.

The Brooklyn's reduction, although not equal to the superb quality of the Walters' highly articulated surface, nevertheless has more surface detail than the larger version. It is possible that in the process of making a mechanical reduction the elements of the model are compressed, giving the effect of a more detailed surface than the larger original model.

Bibliography: Quai des Célestins, 4, 1865, nos. 101, 102; Paris, 1876, no. 696; Paris, 1889, nos. 338, 371, 430; New York, 1889, nos. 75, 244, 301, 302, 388, 442; De Kay, 1889, p. 14, no. 12 (ill.); San Antonio, 1965, no. 24 (ill.); London, 1972, no. 40 (ill.); Paris, March 13, 1973, no. 12 (ill.); Pivar, 1974, p. 162, A93; Zoubaloff, n.d., p. 39, no. 1048.

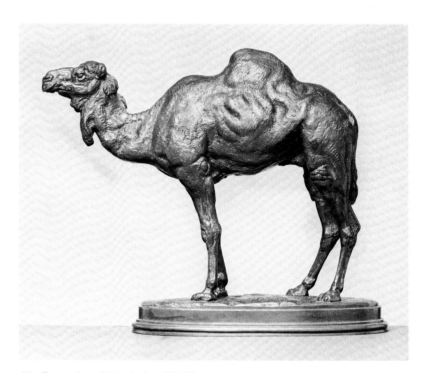

25a Dromedary of Algeria (no. 27.102)
Walters Art Gallery, Baltimore

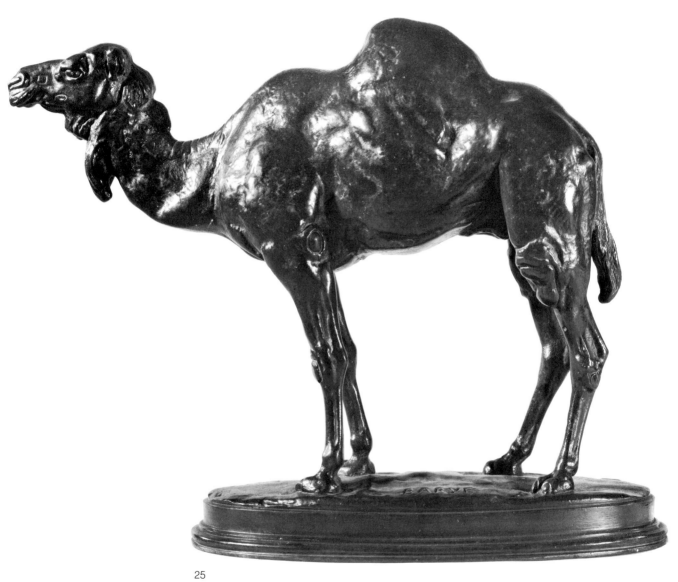

25

26
Walking Wolf (Loup marchant)

Bronze, 24.3 x 38.3 cm
Markings:
Side of base, proper right center: BARYE
Henry Dexter Sharpe Collection, 1956.159

Sand cast in two parts, this sculpture has a green patina. The detail is good, particularly the simulation of fur on the surface of the cast.

The Walters' cast (no. 27.65), however, is superb, with a brown patina and an even more highly articulated surface. A plaque on a special marble base states that Barye had given this bronze to his friend Théodore Rousseau.

Dimensions of both casts are close. The Fogg cast is once removed in size from the Walters, which could indicate that the Walters cast was the modèle from which the Fogg cast was made.

A cast in the Corcoran Gallery of Art (no. 73.95) has dimensions similar to the Fogg's and could have come from the same edition. The crisp surface detail of all three casts demonstrates the superb quality for which the true Barye bronzes were famous.

A cast of the *Walking Wolf* in the Brooklyn Museum (no. 10.165) is of poor quality with great loss of surface detail. Even the wolf's teeth are thinner and more pointed. The base is lost-wax and although otherwise the same as the Fogg, Walters, and Corcoran casts, the wolf is mounted in a reversed position upon it. The Brooklyn cast measures 23.8 x 37.8 cm, appreciably smaller than the others and, therefore, is possibly a surmoulage.

The *Walking Wolf* is listed as no. 192, 24 x 32 cm in the last Barye sales catalogue (Quai des Célestins, 4). A bronze modèle and its plaster were sold (no. 611) at the Hôtel Drouot Barye sale in 1876. Two bronze casts (nos. 341, 475) are listed in the 1889 École des Beaux-Arts exhibition catalogue. The dimensions given are 27 x 36 cm and 24 x 32 cm.

Bibliography: Quai des Célestins, 4, 1865, no. 192; Paris, 1876, no. 611; Paris, 1884, no. 32; Paris, 1889, nos. 341, 475; New York, 1889, nos. 59, 179, 225; De Kay, 1889, p. 117, no. 80 (ill.); Washington, 1939, p. 119, no. 764; San Antonio, 1965, no. 47; Benge, 1969, pp. 318–320, no. 108b, fig. 87; Paris, March 19, 1973, no. M; Pivar, 1974, p. 118, A32.

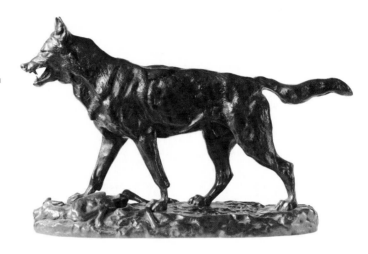

26a Growling Wolf (no. 10.165)
The Brooklyn Museum, Purchased by Friends of the Museum by Special Subscription

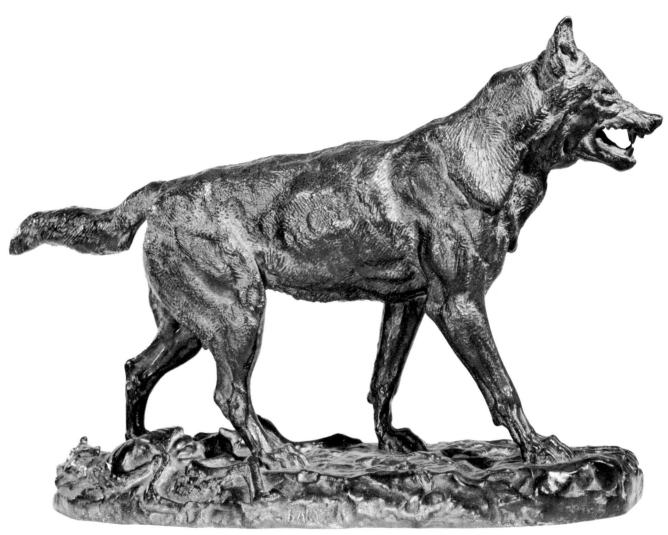

26

27
Wolf Caught in a Trap (Loup pris au piège)

Bronze, 11.6 x 12.9 cm
Markings:
Side of base, proper right front: BARYE
Henry Dexter Sharpe Collection, 1956.158

Sand cast in two parts, this small animal has a mottled green patina over brown. There is little or no evidence of cold working, although the detailed texture of the animal's fur is remarkable. Also remarkable is the sharp expression of pain reproduced with unusual clarity on a sculpture of this scale.

Benge notes only three casts of this subject in American collections. In addition to the Fogg's, there is one in the Brooklyn Museum and one in the Corcoran Gallery of Art. It is listed as no. 193 under "new models" in the last Barye sales catalogue (Quai des Célestins, 4). The dimensions are given as 12 x 13 cm. Two bronze casts also are listed in the 1889 École des Beaux-Arts exhibition catalogue, and two in the Barye Monument Association catalogue of the same year.

An examination of the Brooklyn Museum's cast (no. 10.134) revealed that its quality is comparable to the Fogg's. It measures 11.4 x 13 cm, and has a dark green patina, less mottled than the Fogg's. Cast in two parts, the base could be a lost-wax cast rather than the more usual sand cast.

Bibliography: Quai des Célestins, 4, 1865, no. 193; Paris, 1876, no. 613; Paris, 1889, nos. 334, 524; New York, 1889, nos. 204, 250; De Kay, 1889, pp. 62–63, no. 41 (ill.); Washington, 1939, no. 789; Benge, 1969, pp. 318–320, no. 199a, fig. 85; New York, 1971, no. 32; London, 1972, no. 75; Paris, March 13, 1973, no. 3; Pivar, 1974, p. 119, A33; Zoubaloff, n.d., p. 17, no. 6717.

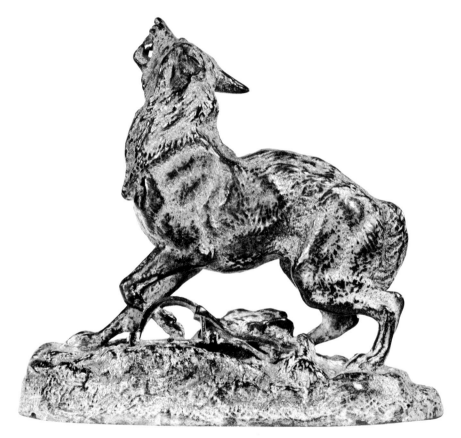

27

28
Lion Devouring a Boar (Lion devorant un sanglier)

Bronze, 16.9 x 28.5 cm
Markings:
Side of base, proper left front: BARYE
Henry Dexter Sharpe Collection, 1956.150

This sculpture was sand cast in approximately three parts. It has a bright green patina, and is a good example of a normal production cast in the customary large 19th-century edition.

The subject first appears in the last Barye sales catalogue under the heading "nouveaux modèles," where it is listed as no. 215, with the dimensions 19 x 32 cm. An unedited bronze and a plaster model entitled *Lion devorant un sanglier* appear as nos. 455 and 456 in the 1876 Barye sale at the Hôtel Drouot. In addition, no. 588 is bronze modèle with its plaster. The 1889 École des Beaux-Arts catalogue includes a bronze cast (no. 344) with the measurements 25 x 36 cm, and a plaster retouched with wax (no. 646).

The plaster and wax modèle next appears as no. 66 in the 1932 George Haviland sales catalogue, with the dimensions 18 x 28 cm. The illustration (pl. XIX) is the same composition as the Fogg's with sharper detail on the lion's mane, the boar's coat, and the tool marks on the base. The larger height dimension of the plaster and wax suggest that the Fogg's cast is twice removed from it, a bronze modèle made from the plaster having served to make the edition casts.

Pivar illustrates three interpretations of the Lion and Boar theme: *Lion Devouring a Boar*, similar to the Fogg's, and *Lion and Boar* in which the boar's head is raised (both from French museums) and *Lion Attacking a Boar* in the Walters Art Gallery. The lion of the Walters cast is in a vertical position similar to the *Lion and Serpent* (no. 14) and is devouring the raised hind quarter of his prey.

Lion Devouring a Boar with the dimensions 7¼ x 11" (18.5 x 28 cm) is listed as no. 358 of the R. Austin Robertson Collection in the exhibition catalogue of the Barye Monument Association. The dimensions suggest that this cast could be the Fogg's elongated oval composition rather than the Walters' more vertical, round composition.

Bibliography: Quai des Célestins, 4, 1865, no. 215; Paris, 1876, nos. 455, 456, 588; Paris, 1889, nos. 344, 646; New York, 1889, no. 358; Paris, 1932, no. 66, pl. XIX; Benge, 1969, pp. 321–323, no. 174, fig. 110; Pivar, 1974, p. 134, A51.

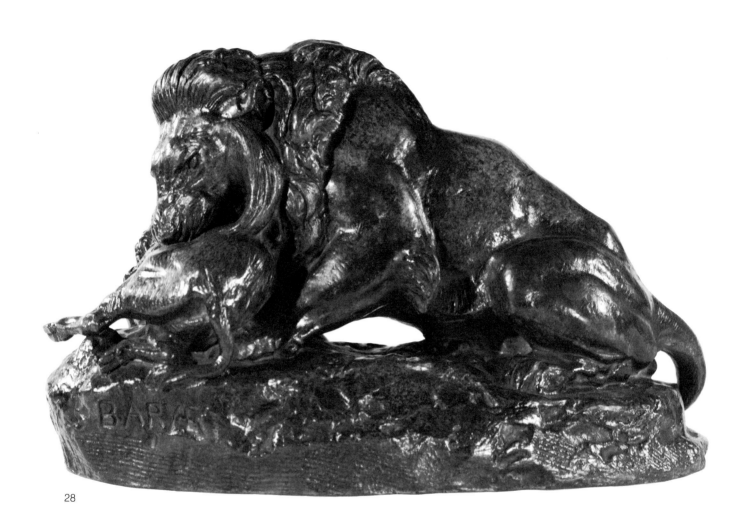

28

29
Striding Lion (Lion qui marche?)

Bronze, 34.3 x 47 cm
Markings:
Top of base, proper left rear: BARYE
Grenville L. Winthrop Bequest, 1943.1126

Sand cast in two sections, this *Walking Lion* has a
dark brown patina.

At first glance, the Fogg lion appears to be a cast of
one of Barye's most popular subjects, illustrated in
Ballu, De Kay (on the title page), Alexandre, Benge
and Pivar, as well as in countless exhibition and sales
catalogues. In fact, no less than nine casts were ex-
hibited by the Barye Monument Society in 1889. The
Walking Lion, usually dated in the mid-thirties,
appears in all six Barye sales catalogues with the
dimensions 23 x 40 cm. In the catalogues of Rue des
Fossés-Saint-Victor, 13, and of Quai des Célestins,
10, it is listed as a pendant to *Walking Tiger* of the
same dimensions.

Closer examination of the Fogg cast revealed that it is
significantly different from all the *Walking Lions* illus-
trated and from the casts at the Walters, the Corco-
ran, and the Brooklyn Museum. The head is higher
and the mouth more open, as though emitting a growl
or roar. The tail is curved inward toward the proper
left haunch and, most puzzling of all, the animal
locomotion is different, for the two proper left legs are
close together and the proper right legs are splayed
out beyond them. Unlike the other *Walking Lion* casts
studied, the Fogg's is heavily embellished with tex-
tural chasing, especially noticeable on the lion's head,
back, tail, and proper right forepaw. It is also an
exceptionally heavy cast.

A detailed comparison was made with the Brooklyn
Museum's *Walking Lion*, which is like the Walters',
the Corcoran's, and those illustrated in the Barye
literature. It measures 23 x 41.5 cm, considerably less
than the Fogg's, and has a green patina. The BARYE
signature is on top of the base, proper left front
whereas the Fogg's is on the proper left rear.

A possible solution of the problem of the Fogg lion's
origin is the *Lion with Ibex* (*Lion et bouquetin*), one of
the four colossal stone groups ordered from Barye in
1867 by the city of Marseilles to adorn the entrance to
the Palais Longchamp. A recent photograph of the
stone *Lion with Ibex*, taken in situ, shows the probable
origin of the Fogg's lion. The Marseilles lion has
evidently been disturbed while attacking his prey, for

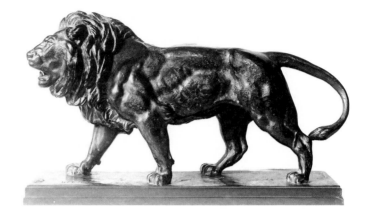

29a Lion Walking (no. 10.207)
Brooklyn Museum, Purchased by Friends of the
Museum by Special Subscription

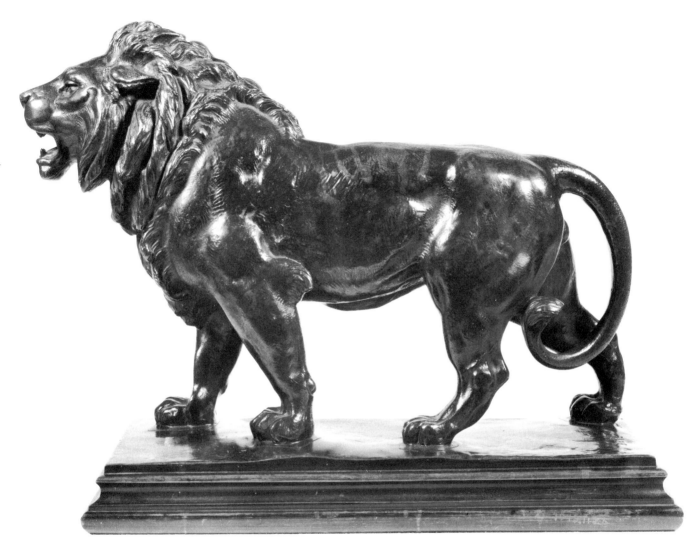

29

his head is raised and his mouth is open in a snarl or roar. The tail curves inward against the proper left flank and the legs striding the ibex are puzzling no longer. The front and back proper left legs are close together; the proper right legs are widely separated by the ibex lying prone between them.

Writing of the four Marseilles stone animal combat groups De Kay remarks: "These colossi were thought so well of that plaster casts of them were afterwards shown in Paris at the Exposition." In fact, no. 120 of the *Christie's East* sales catalogue of March 16, 1982 is a reduced version in bronze of the Marseilles *Lion and Ibex*. Its measurements are 15¼ x 19" (38.7 x 48.2 cm). In the Sotheby sales catalogue of October 29, 1975, the Fogg's Lion is listed as *Striding Lion*, no. 61, with a length of 47 cm, like the Fogg's. Seen at approximately the same scale, the resemblance between the Christie *Lion and Ibex* and the Sotheby (and Fogg's) *Striding Lion* is striking.

Although the position of the legs is different from that of the famous *Walking Lion*, according to the locomotion photographs by Eadweard Muybridge (pl. 133), it represents another stage of the lion's walking gait and is anatomically correct.

Nevertheless, if an admiring sculptor attempted to metamorphose the *Lion et bouquetin* into the famous *Walking Lion* image, creating the Fogg variant, he lacked Barye's talent for depicting the luxuriant lion's mane as well as the anatomical knowledge to render the skeletal detail of the lion's back.

Two versions of *Lion qui marche* are given in the Hôtel Drouot Barye sale of 1876. *Lion qui marche* no. 1 is offered (no. 598) as a bronze modèle with its plaster, and a *Lion qui marche* no. 2 is also listed (no. 656) under bronze modèles.

Bibliography: Paris, 1876, no. 511; Paris, 1889, nos. 343, 623; De Kay, 1889, pp. 111–112; Muybridge, 1957, pl. 133; Pivar, 1974, p. 132, A49; p. 138, A55; New York, October 29, 1975, no. 61 (ill.); New York, March 16, 1982, fig. 120 (ill.).

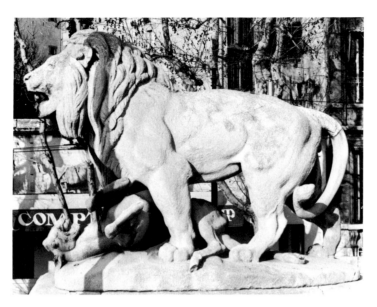

29b Lion et bouquetin
Palais Longchamp, Marseilles

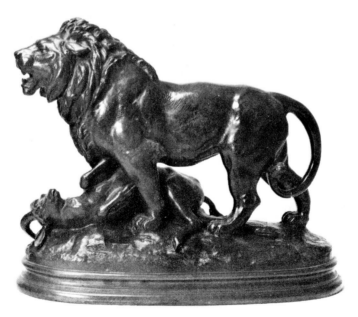

29c A Bronze Group of a Lion with Ibex
Christie's East Catalogue (no. 263), March 16, 1982

Medieval Peasant (Paysan moyen âge)

Bronze, 30.5 x 25.4 cm
Markings:
Top of base, center front: BARYE
Henry Dexter Sharpe Collection, 1956.157

This sculpture is sand cast in two parts. A good cast, with black and green patina, it has excellent detail.

The figure was taken from the group entitled *The Bear Hunt*, one of the five complicated hunt groups Barye created for the table decoration commissioned by the Duc d'Orléans and on which he worked from 1834–1838. An illustration in De Kay, p. 54, shows the completed group consisting of an equestrian figure attacked by bears, which, in turn, are attacked by dogs. The standing peasant wields a sword instead of the staff held by this single figure.

The five hunt groups were cast by Gonon and his two sons, using the lost-wax method. They are unique casts, and were dispersed at the Paris sale of the effects of the Duchesse d'Orléans in January 1853. According to an article by William R. Johnston in *Apollo* (p. 406), W. T. Walters succeeded in acquiring four of the five groups by 1888, and his son Henry acquired the fifth in 1898. All are now installed in the Walters Art Gallery in Baltimore.

Another cast of the single peasant figure in the Corcoran Gallery of Art (no. 74.23) is similar to the Fogg's in quality. It has a dark green patina, and a feather on the proper left side of the hat which does not appear on the *Bear Hunt* figure, and which is missing on the Fogg cast. The height of both casts to the top of the hat (eliminating the feather) is 30.5 cm; but the length of the Corcoran figure is 26.8 cm compared to the Fogg's 25.4 cm. The difference is due to the fact that the staff in the hands of the Fogg figure has been bent, whereas the Corcoran peasant's staff is straight. De Kay, 1889, no. 55, shows the *Medieval Peasant* as a single figure which is like the Corcoran cast, with a feather on the left side of the hat and a straight, not curved, staff.

The *Paysan Moyen Âge* appears in the last Barye sales catalogue, and is offered as a bronze modèle with its plaster (no. 687) at the 1876 Barye sale at the Hôtel Drouot. A bronze cast (no. 438) and a bronze modèle (no. 523) are listed in the 1889 École des Beaux-Arts catalogue.

Bibliography: Quai des Célestins, 4, 1865, no. 186; Paris, 1876, no. 687; De Kay, 1889, p. 118, no. 55 (ill.); Paris, 1889, nos. 438, 523; New York, 1889, no. 187; Ballu, 1890, pp. 56–58; Washington, 1939, p. 119, no. 772; San Antonio, 1965, no. 43; Benge, 1969, p. 62, no. 168d, fig. 187.

Tiger Attacking a Peacock

Cast plaster and wax, 16.5 x 42.5 cm
Markings:
Top of base, proper left center: BARYE
Grenville L. Winthrop Bequest, 1943.1023

Acquired by Martin Birnbaum for Mr. Winthrop at a Parke-Bernet auction on October 18, 1940, Mr. Birnbaum wrote with some excitement to his client in a letter now in the Fogg's Archives, "I secured the *Tiger and Peacock*, Barye's superb original model, for the low sum of 440.00! In Paris, it would have cost (if such an item were available) between two and three thousand dollars." In the same letter, Birnbaum mentions that "the beak of the peacock ought to be repaired (I am sure Manship would do it)."

Mr. Birnbaum's enthusiasm is justified, since the *Tiger Attacking a Peacock* represents an early step in the making of a "Barye bronze." The plaster and wax modeling procedure was apparently unique to Barye. His use of the technique is confirmed by the presence of several such plaster and wax originals in American and French collections.

Using both cast and direct plaster as a foundation, the tiger is covered with wax, a material softer than the plaster, and more easily modeled, carved and incised so that the fine details of surface texture can be reproduced exactly in the bronze to be cast from it. This unique bronze, in turn, would serve as a modèle from which an edition of bronze casts could be produced. Traces of French sand inside the base of the Fogg's plaster and wax model confirm that it was used to make a sand mold, the first step in the bronze sand-casting process.

Key measurements indicate that the Tiger is related in size to the vertical tiger figure climbing up the right side of the elephant in the *Tiger Hunt* group, which was cast in 1836 as the center-piece of the table decoration commissioned by the Duc d'Orléans. The adaptation of the vertical tiger to the horizontal figure pouncing on its prey explains the need for the alterations which appear on this model. Both the fore- and hind legs have been lengthened, the tiger's left haunch is pressed inward, and its head has been brought close to the peacock by means of a wedge of plaster inserted into the nape of the neck.

The Fogg's plaster and wax model is illustrated in Saunier with the title *Lioness Seizing a Peacock*. From this illustration it is clear that the Fogg's model has suffered some damage. The peacock's bill is indeed broken off and in addition its proper left wing is missing. (Evidently the repairs Mr. Birnbaum suggested were never made.) Saunier notes that it is an "unedited plaster, collection Zoubaloff."

Two bronze casts in American museums, however, indicate that an edition was made. The bronzes in the Nelson Gallery-Atkins Museum in Kansas City (no. 65–6/1) and the San Francisco Palace of the Legion of Honor (no. 1967.10) were cast by the Barbedienne foundry, and on both casts the peacock's bill and wing are intact, as in Saunier's illustration.

Since the *Tiger Devouring a Peacock* does not appear in any extant Barye sales catalogues, the Barbedienne edition is presumably the only one. Barbedienne probably acquired the plaster and wax model in the Barye sale at the Hôtel Drouot in 1876 just after his death. It is listed as no. 548 in the Drouot catalogue and the subject appears again in bronze on p. 3 of Barbedienne's own 1893 catalogue of works by Barye. Barbedienne exhibited his plaster and wax modèle in the 1889 exhibition at the École des Beaux-Arts. It is no. 589 in the catalogue.

The Barbedienne bronze edition is evidently small, since, so far, only the two casts in the American museums are known. The damage to the modèle occurred after these bronzes were cast, possibly during the process of casting the edition. Perhaps Barbedienne never made a master bronze modèle as Barye would have done for a large edition. Instead, he could have used the plaster and wax directly as a modèle.

Bibliography: Paris, 1876, no. 548; Paris, 1889, no. 589; Barbedienne, 1893, p. 3; Saunier, 1925, pl. 22; Benge, 1969, pp. 274–278, no. 265, fig. 72; London, 1972, p. 41 (ill.); Pivar, 1974, p. 144, A64; Wasserman, 1975, pp. 85–88, p. 84 (ill.).

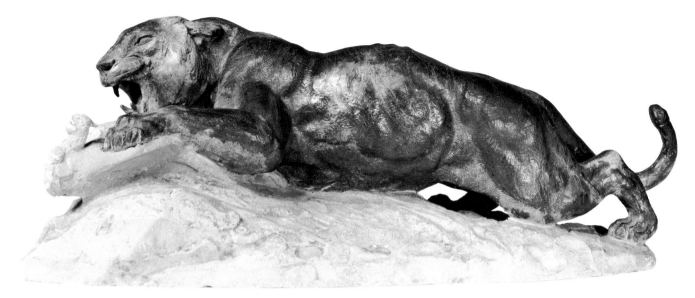

31

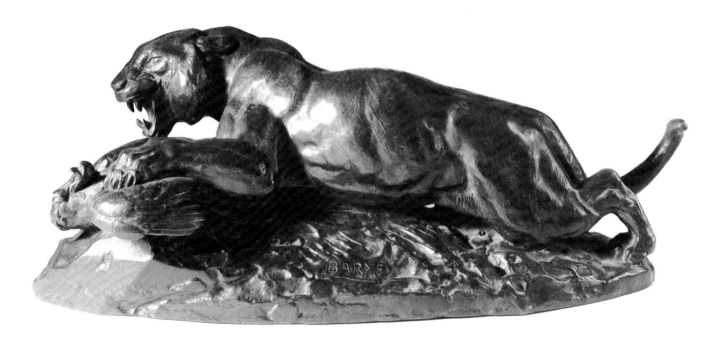

31a Tiger Attacking a Peacock (no. 1967.10)
*The Fine Arts Museums of San Francisco, Gift of
Mr. and Mrs. Walter A. Haas*

Appendix A
Sculpture of questionable attribution and
surmoulages

I, II

Seated Lion *Reduction no. 1 (Lion assis)*

Bronze, 34.9 x 29.8 cm
Markings:
Top of base, proper left rear corner: BARYE
Henry Dexter Sharpe Collection, 1956.163 and
1956.164

Barye's life-size *Lion assis*, his last monumental work
for the house of Orléans, was cast in 1847 and placed
in the Tuileries Gardens in 1848. According to Ballu
(p. 97), it was moved to the Quai of the Tuileries in
1867, and, to Barye's disappointment and distress,
the state would not commission an original
companion piece, but had a reversed mechanical
reproduction made of his first lion. It is interesting to
note that the signature on the reversal copy is also
reversed. Today the pair may be seen at one of the
Quai entrances to the Louvre.

The Fogg's *Seated Lions* are lost-wax casts with a
green over brown patina. Compared with a cast of the
same subject in the same scale at the Walters Art
Gallery, they appear to be surmoulages, as they are
conspicuously lacking in detail.

A close examination of the Walters' cast (no. 27.120)
reveals that it was sand cast in three parts, has a
brown patina and every detail of face and fur is
sharply reproduced. A line across the nose on the
Walters cast, for instance, has almost disappeared on
the Fogg casts. Scratches on the base of the Walters
cast, caused by the making of molds, indicate that it
could be a modèle. Furthermore, the letters MODE in
black paint underneath the base seem to confirm this.

The Walters cast measurements of 36.4 x 33 cm
further indicate that the Fogg casts are surmoulages,
probably twice removed.

The Brooklyn Museum has two seated lions (nos.
10.179, 10.180) with essentially the same dimensions
as the Walters' (36.3 x 33 cm). One has a green over
black patina, the other a red-brown patina. Both are
good casts with sharp detail, and are sand cast in two
parts.

The *Seated Lion* is a popular image, and reductions
were made in several sizes. Barye's last catalogue
(Quai des Célestins, 4) lists four reduced sizes of the
Lion assis: Reduction no. 1, 37 cm high; Reduction

no. 2, 21 cm high; Reduction nos. 3 and 4, 19 cm
high. The bronze modèles and their plasters for all
four reductions were offered as nos. 663–666 in the
Hôtel Drouot Barye sale of 1876. In addition, a bronze
model with its plaster of the "Lion des Tuileries" is
listed as no. 700. In the 1889 catalogue of the École
des Beaux-Arts exhibition, six casts of *Lion assis* are
listed, including a bronze and a plaster model belong-
ing to Barbedienne and a wax belonging to the
painter Bonnat.

Bibliography: Guillaume, n.d., pp. 206, 222; 12, Rue
Chaptal, n.d., nos. 66, 99; Rue Saint-Anastase, 10,
n.d., nos. 66, 99; Rue de Boulogne, No. 6, 1847–
1848, nos. 66, 99; Planche, 1851, pp. 50–51; Rue de
Fossés-Saint-Victor, 13, 1855, no. 40; Quai des
Célestins, 10, 1855, no. 48; Quai des Célestins, 4,
1865, no. 45, 46, 47, 48; Mantz, 1867, p. 119; Paris,
1876, nos. 663, 664, 665, 666, 700; Paris, 1886, nos.
2; Paris, 1889, nos. 89bis, 240, 251, 381, 571, 643;
New York, 1889, nos. 33, 138, 222, 223, 285, 335,
407; De Kay, 1889, nos. 57, 61, 62 (ills.); Alexandre,
1889, p. 21 (ill.); Smith, 1902, pp. 214–215, p. 214
facing (ill.); Masters in Art, 1904, vol. 5, pl. 1;
Baltimore, 1911, nos. 429, 583; Saunier, 1925, pl. 10;
Washington, 1939, p. 117, no. 723; Hubert, 1956, p.
229; Baltimore, 1965, nos. 375–377; San Antonio,
1965, no. 11; Benge, 1969, pp. 320–321, no. 55g,h,
fig. 100; Mackay, 1973, p. 31; Pivar, 1974, p. 126,
A41; Johnston, 1974, p. 404; Wasserman, 1975, p.
78.

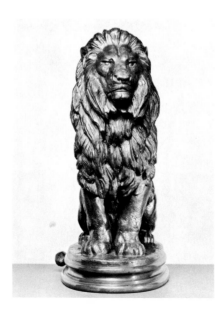

Ia. Seated Lion *(27.120)*
Walters Art Gallery, Baltimore

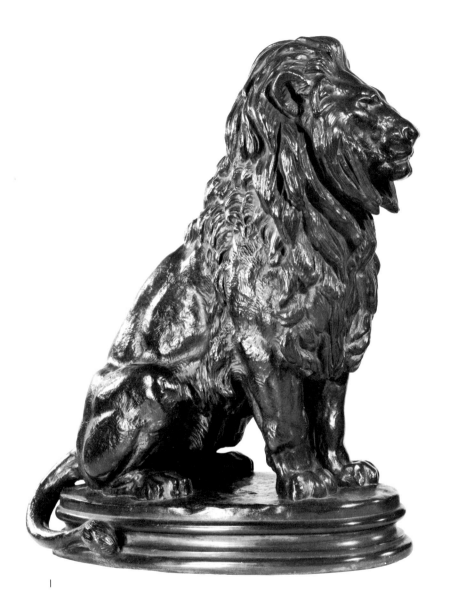

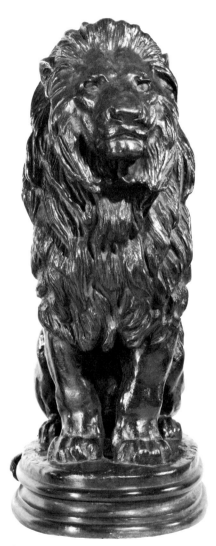

I

II

Elephant of Cochin China (Éléphant de Cochinchine)

Bronze 13.4 x 18.1 cm
Markings:
Top of base, proper left center: BARYE
Henry Dexter Sharpe Collection, 1956.143

This is a one-piece lost-wax cast with a brown patina. Even without comparison with the Walters cast, the lack of detail is obvious.

The Walters cast (no. 27.99) is superb. It is sand cast in at least two sections and also has a brown patina. The markings on the elephant's trunk could be cold worked. Numerous scratches on the base caused by mold-making indicate that this could be a modèle used for making the edition. An average of the measurements taken from several points on the sculpture show that the Fogg cast is 6.7 percent smaller than the Walters', or probably three times removed from it. This would further indicate that the Walters cast is likely to be a modèle, the Fogg's a surmoulage taken from one of the edited casts. The Walters cast is, in fact, listed as "21. Elephant of Cochin-China-model" in the 1889 Barye Monument Association catalogue, with the dimensions 6 x 10" (15.2 x 25.5 cm).

An interesting note is the different treatments of the elephant's tail. On the Fogg's cast the tail is connected to the elephant's proper left back leg, whereas the Walter's tail hangs free.

Barye listed this subject as no. 212 under "new models" in his last sales catalogue (Quai des Célestins, 4). Its dimensions are given as 14 x 19 cm and it was offered as a pendant to the *Elephant of Senegal* with the same dimensions. Pivar notes that this subject was cast by the Brame foundry. In fact, the bronze modèle with its plaster were offered as no. 675 at the 1876 Barye sale at the Hôtel Drouot.

The last Barye catalogue also offers an *Elephant of Asia* no. 90 and an *Elephant of Africa* no. 91 (14 x 16 cm), which presumably are different subjects. Benge, however, places *Indian Elephant* or *Elephant of Cochin China*: *èléphant d'Asie, éléphant de Cochinchine* as the same under no. 30 of his catalogue raisonné and illustrates the Asian elephant. He uses the same title for no. 31 where he lists the Fogg example as 31b and illustrates the Walters cast of the Fogg version discussed above.

Ballu, p. 47, cautions that the *Elephant of Asia* should not be confused with the *Elephant of Cochin-China* which he describes as a masterpiece of grace "of lightness and spirit . . . this elephant both agile and heavy . . . which displaces the air while trotting, and whose large flat ears arise into space." He dates the *Elephant of Asia* to the Salon of 1833 and describes its attitude as calmer. Unfortunately, however, there are no illustrations to supplement the verbal descriptions, thereby clarifying this confusion of elephants.

Bibliography: Quai des Célestins, 4, 1865, no. 212; Paris, 1876, no. 675; Paris, 1889, no. 335; New York, 1889, nos. 21, 316; Ballu, 1890, p. 47; Baltimore, 1911, no. 493; Benge, 1969, pp. 331–336, no. 31c, fig. 157; New York, 1971, no. 21 (ill.); Pivar, 1974, p. 160, A91.

IIIa. Indian Elephant *(27.99)*
Walters Art Gallery, Baltimore

III

Panther of Tunis (Panthère de Tunis)

Cast brass, 13.3 x 26.7 cm
Markings:
Side of base proper left front: BARYE
Henry Dexter Sharpe Collection, 1956.169

The bright green color of this sculpture was produced by paint. The object is brass, which is far more difficult to patinate chemically than bronze. It most closely resembles a plaster and wax model in the Walters Collection, which is 10 cm high, and a bronze cast closely related to it (no. 27.44).

A similar panther in the Corcoran Gallery of Art (no. 73.60) measures 13.6 x 27.5 cm, or slightly larger than the Fogg's. It is bronze, sand cast in one piece, and has a brown-black patina. The detail is far superior to the Fogg's brass cast. There is evidence of cold working on the panther's chin.

In the Barye sales catalogue of the Rue des Fossés-Saint-Victor a *Panthère de l'Inde* and its pendant *Panthère de Tunis* make their appearance. Their dimensions are given as 10 x 20 cm. In the last two Barye sales catalogues issued at the Quai des Célestins, 10, and 4, the paired *Panthère de l'Inde* and the *Panthère de Tunis* are given dimensions 13 x 25 cm. Reductions of both are added with the dimensions 10 x 20 cm, their original size in the previous catalogue. In the Hôtel Drouot sale of Barye's works, *Panthère de Tunis* (no. 443) was offered in a "galvano" cast under "Bronzes cast from the plaster which served as model." It was also offered as no. 706 "a lot including a *Panthère de Tunis*, no. 1, ditto, no. 2. Models in bronze with their plaster." Bronze models of no. 1 and no. 2 were loaned by Barbedienne to the École des Beaux-Arts exhibition of 1889, which included also a plaster model and a bronze cast.

A plaster model with wax from the Walters Collection (no. 27.46) is listed in the Barye Monument Association exhibition as no. 112, *Panther of Tunis*, with the dimensions 4 x 8″ (10 x 20 cm) and the notation "Reduction." In the same catalogue a Walters bronze, no. 27, is entitled *Panther of Tunis* (Reduction) with the dimensions 3¾ x 7½″ or (9.5 x 19 cm), which would make it once removed from the model, and possibly cast from it. These measurements would indeed compare with the reduced version of *Panther of Tunis* in Barye's last two sales catalogues.

De Kay's book of 1889 illustrates the same panther as the Walters plaster and wax model (no. 39 opposite p. 124). The title is given as *Panther of Tunis Couchant* and the height 3¾″ (9.5 cm). Benge lists no. 69, *Panther of Tunis, Recumbent* from the Lucas Collection, with the dimensions 5½ x 10⅞″ (13 x 25 cm). He lists the Fogg's brass Panther as 69a under the Lucas cast. Pivar, on the other hand, identifies the Walters plaster and wax model as A71 *Reclining Panther* with the dimensions 7 x 18 cm.

The cast brass panther in the Fogg Collection is closest in size to the *Panther of Tunis* in the last two Barye sales catalogues, not its reduction. The Fogg's, in fact, is slightly larger than Barye's listing and somewhat shorter in length than the Corcoran's bronze. It is crude when compared to the Corcoran's and to the Walters' model for the reduction and its related bronze. The model for the Fogg's version is unknown, and is quite possibly an unauthorized free-hand adaptation of Barye's original.

Bibliography: Rue de Fossés-Saint-Victor, 13, 1855, no. 58; Quai des Célestins, 10, 1855, nos. 68, 70; Quai des Célestins, 4, 1865, nos. 66, 68; Paris, 1876, nos. 443, 706; Paris, 1886, no. 29; Paris, 1889, nos. 17, 18, 151, 626; New York, 1889, nos. 27, 112, 149, 433, 443; De Kay, 1889, p. 124, no. 39 (ill.); Barbedienne, 1893, p. 4; Baltimore, 1911, nos. 579, 590; Washington, 1939, p. 118, no. 734; Baltimore, 1965, nos. 390, 391; San Antonio, 1965, no. 20; Benge, 1969, pp. 317–318, no. 69a; London, 1972, no. 24; Mackay, 1973, p. 31; Pivar, 1974, p. 149, A71; Johnston, 1974, p. 404; Wasserman, 1975, p. 87, nos. 7, 8 (ills.).

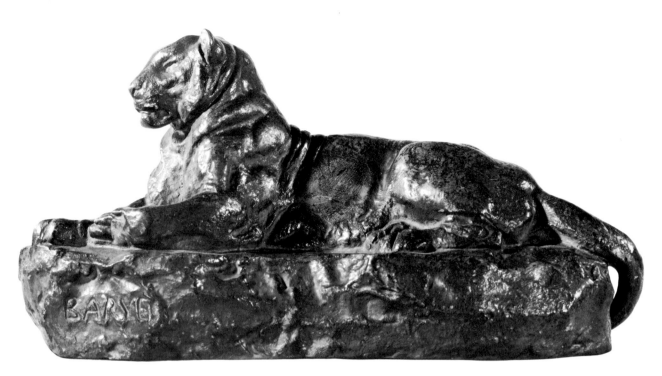

IV

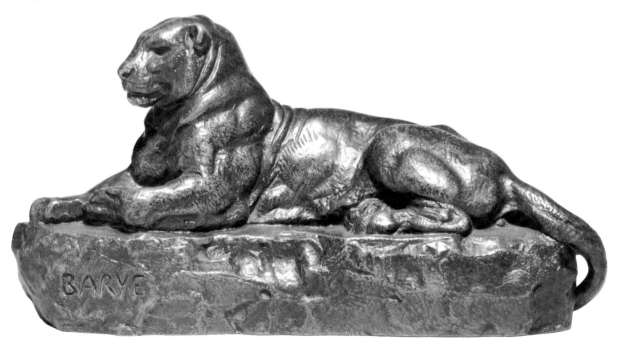

IVa. Panther of Tunis *(27.44)*
Walters Art Gallery, Baltimore

85

V
Ocelot Carrying off a Heron (Un Ocelot
emportant un héron)

Bronze, 17.2 x 30.2 cm
Markings:
Top of base, proper left rear: BARYE
Henry Dexter Sharpe Collection, 1956.168

This subject appears in all six Barye sales catalogues.
The Fogg's lost-wax cast with black patina shows very
little detail. Compared with the same subject in the
Walters Art Gallery (no. 27.131) the measurements of
the Fogg cast are an average of three to five percent
smaller. The Walters cast has a thin brown patina and
is sand cast in about five sections. It is a light cast of
good quality, but appears unfinished in places. The
mold lines, for instance, have not been chased and
lines along the heron's wings have been left open.
The bird's feathers and the lines of its neck are sharp,
whereas on the Fogg cast they are soft and less
clearly defined.

A cast of this subject in the Corcoran Gallery (no.
73.66) has dimensions close to the Walters example.
It is sand cast in two sections and has a dark green
over black patina. The details on both animal and
bird, and on passages of the base are excellent.

The fact that the Walters' is a light-weight cast in five
sections, and the Corcoran's is heavier and made in
two sections could indicate that the Walters' is the
modèle from which the Corcoran's sculpture, with
similar dimensions, was cast. The significant differ-
ence in measurements, loss of detail and lost-wax
casting, which was generally a later technique in
19th-century France, would indicate that the Fogg's
cast is a surmoulage.

*Bibliography: 12, Rue Chaptal, n.d., no. 59; Rue Saint-
Anastase, 10, n.d., no. 59; Rue de Boulogne, No. 6,
1847–1848, no. 59; Rue de Fossés-Saint-Victor, 13,
1855, no. 68; Quai des Célestins, 10, 1855, no. 82;
Quai des Célestins, 4, 1865, no. 80; Paris, 1876, no.
590; Paris, 1889, nos. 13, 101, 153, 375, 440; New
York, 1889, nos. 52, 155, 292; Alexandre, 1889, p. 66;
De Kay, 1889, p. 22, no. 18 (ill.); Ballu, 1890, p. 89, p.
90 (ill.); Paris, 1891, no. 12; Barbedienne, 1893, p. 4;
Baltimore, 1911, no. 415; Washington, 1939, p. 118,
no. 740; Paris, 1956–1957, no. 18; Baltimore, 1965,
no. 388; Benge, 1969, pp. 359–360, no. 139c, fig.
207; New York, 1971, no. 58; London, 1972, no. 85;
Paris, March 13, 1973, no. 30 (ill.); Paris, March 19,
1973, no. N (ill.).*

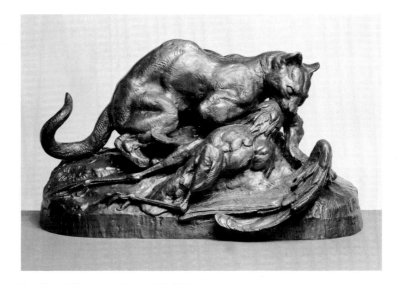

Va. Ocelot Carrying a Heron *(27.131)*
Walters Art Gallery, Baltimore

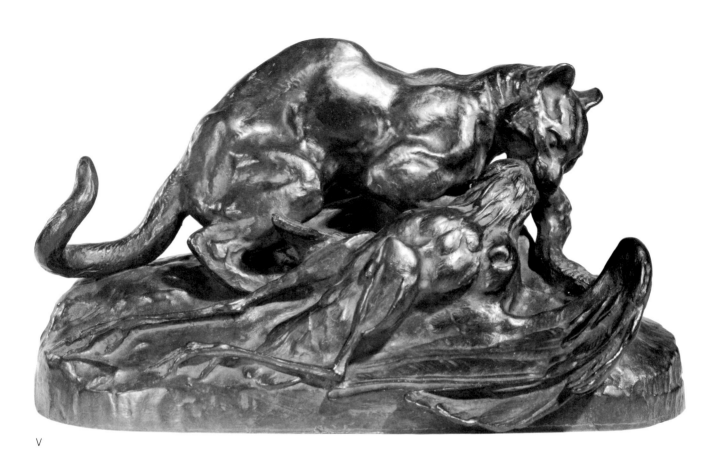

V

Bronze, 17.8 x 25.9 cm
Markings:
Top of base, proper left center: BARYE
Henry Dexter Sharpe Collection, 1956.148

A lost-wax cast in one piece, this animal has a black patina, which closely resembles the patination of the *Ocelot Carrying Off a Heron* (no. V) and the *Turkish Horse* (no. 20). The light weight, the lack of surface detail, and the fact that other surmoulages in the collection have all been lost-wax casts would suggest that this sculpture also is a surmoulage.

The Walters does not have this subject, but rather the humorous group, *Ape Mounted on a Gnu*, which is also listed in the Louvre's Barye exhibition catalogue of 1956–1957. The Walters' gnu is a more robust animal with thicker neck and larger head, strenuously objecting to the ape on his back, who is holding his tail. The Fogg's *Gnu* is more delicate and decorative.

The Fogg's *Gnu* is listed in Glen F. Benge's dissertation (201d) under *Ape Riding a Gnu* (Fragment). It is listed in Stuart Pivar's *The Barye Bronzes* (no. A2, p. 38) with the notation that it was edited by the Brame foundry. Pivar illustrates the Fogg *Gnu* on p. 97. It is also listed in Barye's last catalogue (Quai des Célestins, 4) as no. 203, with the dimensions 19 x 22 cm under the heading "new models." No other cast has been found to date in American collections, although the subject appears in three sales catalogues at the Hôtel Drouot; the Barye sale of 1876, the Barye sale of 1884, and the Sichel sale of 1886. Unfortunately, all are unillustrated. It is interesting to note that in the Barye sale of 1876 a bronze modèle of *Singe monté sur un gnou* is no. 697 in the catalogue and no. 698 is listed as the bronze model of the *Gnou*.

If the *Gnu* offered by Barye is like the *Ape Riding on a Gnu* without the ape, then the Fogg *Gnu* is a different animal; a gentler more delicate version, perhaps inspired by Barye rather than modeled by him.

Bibliography: Quai des Célestins, 4, 1865, no. 203; Paris, 1876, no. 698; Paris, 1884, no. 39; Paris, 1886, no. 17; San Antonio, 1965, no. 37; Benge, 1969, p. 532, no. 201d; Pivar, 1974, p. 97, A2.

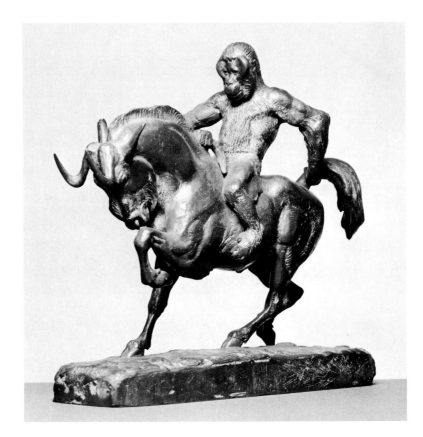

VIa. Ape Riding a Gnu *(27.121)*
Walters Art Gallery, Baltimore

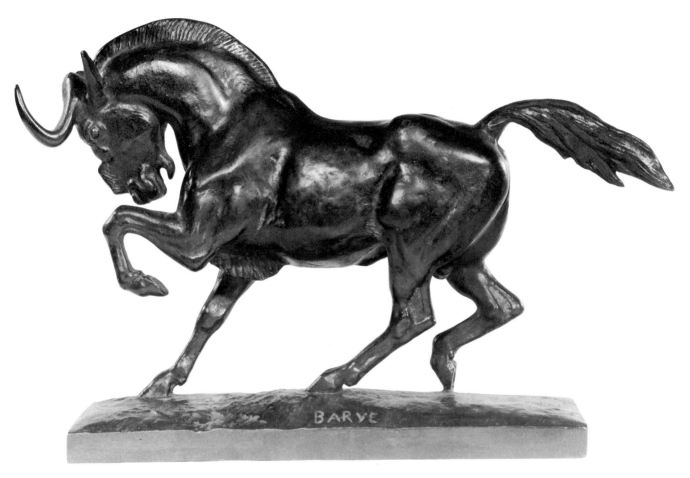

VI

Bear on a Tree, Eating an Owl (Ours monté sur un arbre, mangeant un hibou)

Bronze, 18.7 x 17.2 cm
Markings:
Side of base, proper right front: BARYE
Henry Dexter Sharpe Collection, 1956.149

This is a lost-wax cast with a green and brown patina. The surface is grainy.

The Walters version (no. 27.78) is a sand cast with traces of black sand investment. It has a green patina with some brown. The quality of the cast is similar to the Fogg's with perhaps sharper fur detail on the bear's back and more detail in the face and eyes.

Measurements of the two casts taken in several places show a shrinkage factor on the Fogg cast between two and four percent, which would make it twice removed from the Walters cast, hence probably a surmoulage. It should be pointed out, however, that in addition to the shrinkage of cooling bronze there is a second shrinkage factor, which occurs in the making of the waxes used in the lost-wax casting procedure.

Examination of the cast in the Brooklyn Museum (no. 10.110) seems to reinforce the possibility that the Fogg's cast is a surmoulage. Measurements taken at several points are the same as the Walters'. Like the Walters cast, the Brooklyn's has better detail on the bear's back, face and eyes and the owl is sharper than on the Fogg cast. It is sand cast with black over red-brown patina.

This subject is listed as no. 214 under "new models" in the last Barye sales catalogue (Quai des Célestins, 4). The height is given as 20 cm which is slightly larger than the Walters' (19.1 cm), Brooklyn's (19 cm), and the Fogg's (18.7 cm). It is listed as a bronze modèle with its plaster in the 1876 Barye sale at the Hôtel Drouot.

Bibliography: Quai des Célestins, 4, 1865, no. 214; Paris, 1876, no. 604; Paris, 1884, no. 42; New York, 1889, nos. 241, 361; De Kay, 1889, p. 46, no. 31 (ill.); San Antonio, 1965, no. 57; Benge, 1969, pp. 359–360, no. 109a, fig. 169; London, 1972, no. 74; Paris, March 19, 1973, no. O; Pivar, 1974, p. 105, A11.

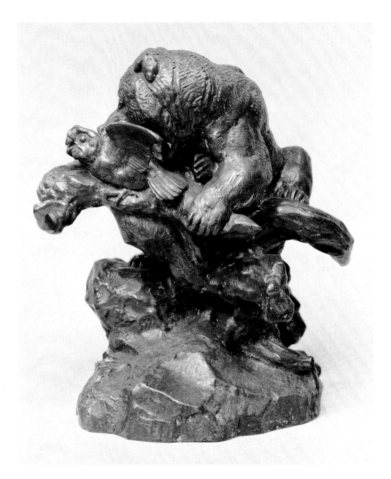

VIIa. Bear on a Tree, Devouring an Owl *(27.78)*
Walters Art Gallery, Baltimore

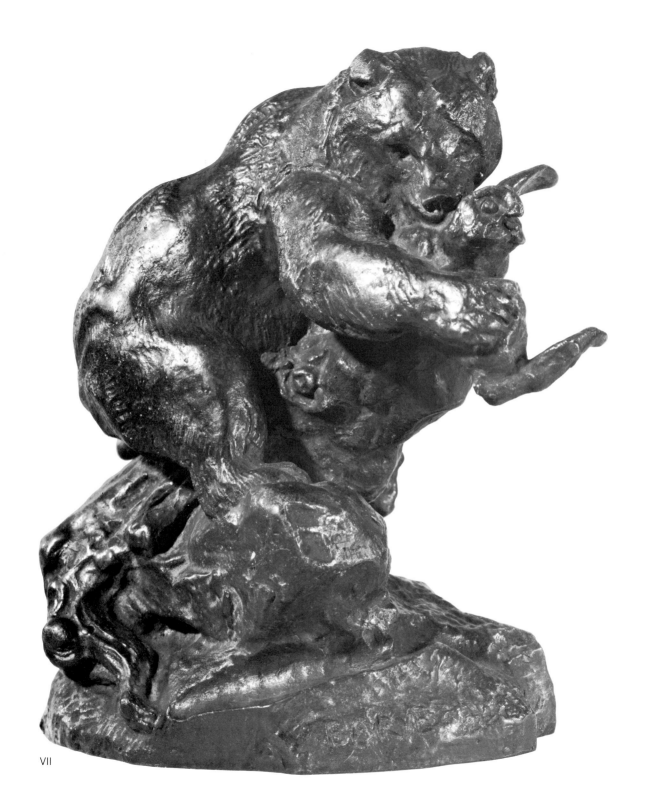

Bronze, 12.6 x 7 cm
Markings:
Incised side of base, proper left rear: A. BARYE
Gift of Mrs. Deborah L. Riefstahl, 1957.10

This sculpture is sand cast in at least three pieces
and has a black patina highlighted with brown. There
is excellent articulation of the surface achieved, in
part, by much cold working on the lower feathers.

The *Vulture* does not appear in the Barye sales cata-
logues nor is there a cast in the Walters or other early
American collections. So far, the subject has not
appeared in any of the museum collections or auction
catalogues.

The incised signature "A. BARYE" is unusual, and has
been attributed to Barye's son, Alfred, who worked in
his father's foundry and who produced a small body
of animalier subjects on his own.

A biography of Barye in *Masters In Art* (vol. 5, 1904),
p. 404, describes his misfortunes in 1848 when his
creditors "seized his models" thereby closing his
foundry. The article adds "an even greater grief, he
discovered that one of his sons had been base enough
to palm off on purchasers inferior casts, pretending
that they were those finished by his father. . . ."

In a letter to Cyrus J. Lawrence dated May 8, 1906,
George A. Lucas wrote that Barye's son deliberately
used the signatures A. L. BARYE and BARYE on his
own sculpture in an attempt to represent them as the
work of his father. In response to his father's objec-
tion, he used the signatures A. BARYE or L. BARYE.
"So anything holding this last signature you can be
sure of their 'provenance'," Lucas cautioned.

Alfred Barye's acknowledged works are signed
"BARYE fils," or "Alf. BARYE," and many of them are
race horses. An article in *Art News* of December 1975
by Roxana Barry reproduces an Alfred Barye sculp-
ture entitled *Wakuta.* Inspired by the Paris visit of
Buffalo Bill and his Wild West Show, the sculpture,
possibly produced from a poster, depicts an Ameri-
can Indian on a horse. "Barye's limitations as a
sculptor are manifested in his problems in scale: the
Indian's legs are longer than his horse's and the
animal's slender barrel and sloping hindquarters
would support his rider briefly if at all." The author
adds that "the horse is the more commanding
presence of the two."

A white metal cast of an Arab on horseback has
appeared recently on the New York art market. It is
signed "Barye fils" and has the same "problems in
scale" as *Wakuta.* The Arab figure is too large for the
horse, whose delicately raised left front hoof recalls
the pose of the famous *Cheval Turc* by Barye Père.

The *Vulture* appears related to the early animal
sculptures of Antoine-Louis Barye. The pose, in fact,
is similar to the *Marabout* (see no. 8), although the
silhouette is rather rigid. The quality of the cast,
however, is excellent, and could well be the work of a
craftsman trained in the Barye foundry. It has the
virtuoso technique without the liveliness and flare of
the master.

*Bibliography: Benge, 1969, pp. 310–312, no. 107, fig.
59.*

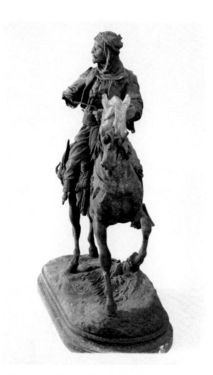

VIIIa. Arab Mounted on a Horse (by Alfred Barye)
*Courtesy of Arthur Eli Huggins, Central Park West,
New York*

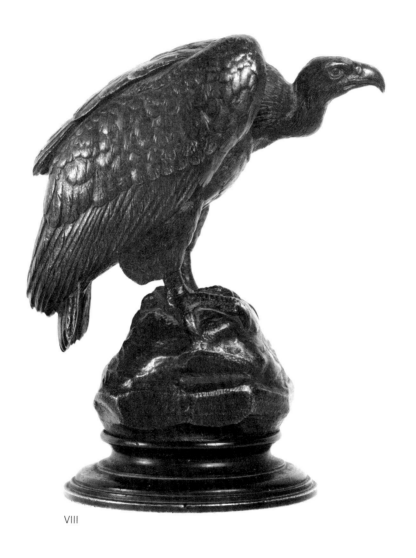

VIII

Appendix B
Checklist for the Drawings

The drawings and watercolors by Barye in the Fogg Museum Collection will be fully catalogued by Agnes Mongan in the forthcoming publication, *Drawings of the French School, First Half of the 19th Century*.

1
Two Tigers Fighting
Watercolor and gouache, black ink with lead-white highlights and heavy varnish on white wove paper.
173 x 239 mm (6¹³/₁₆ x 9⁵/₁₆ in.)
Date: ca. 1833
Signed in black ink at lower right: *Barye*
Grenville L. Winthrop Bequest, 1943.337

2
A Jaguar in a Landscape
Watercolor, gouache, pastel, lead-white highlights and scratching, with light varnish on cream wove paper.

185 x 231 mm (7⁵/₁₆ x 9¹/₁₆ in.)
Date: ca. 1833
Signed in black ink at lower right: *Barye*
Grenville L. Winthrop Bequest, 1943.340

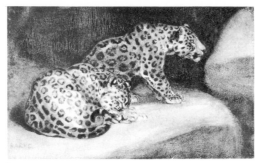

3
Two Jaguars in Their Lair
verso: slight graphite sketch
Watercolor with gouache and varnish on cream wove paper; whiskers on both animals and fur on belly of far jaguar scratched in.
105 x 175 mm (4¹/₈ x 6⁷/₈ in.)
Date: after 1848
Inscribed at lower left, red ink: *BARYE*
Grenville L. Winthrop Bequest, 1943.338

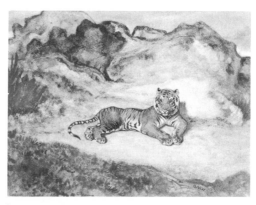

4
Tiger in Its Lair
Watercolor, pastel, black chalk and gouache, lead-white highlights, with some varnishing, on white wove paper.
247 x 332 mm (9¹¹/₁₆ x 13¹/₁₆ in.)
Date: after 1848
The red stamp of the atelier sale at lower right has been overdrawn in black ink.
Grenville L. Winthrop Bequest, 1943.339

5

Two Lionesses Resting
verso: head of a tiger
Graphite and black crayon on tracing paper; mounted on white wove paper.
120 x 205 mm (4³/₄ x 8¹/₄ in.)
Date: after 1848
Old atelier stamp, at lower right.
Marian Harris Phinney Bequest, 1962.20

7

Lion in a Landscape
Watercolor on wove paper.
183 x 255 mm (7³/₈ x 10¹/₁₆ in.)
Inscribed at lower right, black ink: *BARYE*
Frances L. Hofer Bequest, 1979.60

6

Sketches of Two Tigers
Graphite on cream modern laid paper.
178 x 143 mm (7⁹/₁₆ x 5³/₄ in.)
Watermark: Morel Perrier
Anonymous gift in memory of Hyman W. Swetzoff from his Friends, 1968.57

8

Antelope
Watercolor and gouache, green pastel over black chalk on cream wove paper.
122 x 155 mm (sight) (4³/₄ x 6¹/₈ in.)
Anonymous Loan, TL 22175.3

Appendix C
Barye Prints in the Fogg Collection

Barye made few prints. The most complete catalogue of these, found in Loys Delteil's *Le peintre-graveur illustré*, lists one etching and eleven lithographs. To Delteil's twelve can be added one more: a lithograph published in the *Journal des chasseurs* in 1841, an impression of which is found in the Fogg's collection.

The style of Barye's lithographs differs markedly from that of his watercolors. Though bearing witness to ease and competence in the medium, the lithographs are, for the most part, simple, straightforward images. Unlike the heavily-worked watercolors, which display a great interest in complex relationships of tone and color, the lithographs generally keep figures quite separate from ground, while maintaining subtle transitions of tone.

Although little is known about Barye's activities as a printmaker, it is clear that most of his prints were produced for publication in periodicals or albums of lithographs. Four were published in the important journal *L'Artiste*. Roughly half of the prints exist in several states.

<div style="text-align: right">J.S.</div>

1

Etude de tigre (Study of a Tiger), 1832
Lithograph, Delteil 2, 3rd state, on chine appliqué
82 x 160 mm
Purchase, Francis Calley Gray Fund, G8353

The first known state of this lithograph was published in *L'Artiste* in 1832, with Delanois named as printer. The Fogg's third state, published in the series *Souvenirs de l'artiste*, is printed by Berauts.

The pose of the tiger is closely related to that of the wax model *Tigre couché* (Pivar A 67), although the head of the wax tiger is not turned. The treatment of the landscape here is of a remarkable delicacy; the subtle tonal transitions and use of scraping on the stone are signs of a relatively sophisticated understanding of the medium. Compared to prints of similar subject by Delacroix, however, or to more dramatic representations by Barye himself, such as the Fogg's plaster and wax sculpture *Tiger Attacking a Peacock* (no. 31), the *Etude de tigre* appears straightforward and subdued. The small size of the image, and the relatively small scale of the tiger within it, help to create an almost precious effect.

1

2
Le Cerf dix cors (Stag with Ten Antlers), 1841
Lithograph, on chine appliqué
113 x 164 mm
Museum Purchase, M15,455

This print is not listed by Delteil. Another impression, apparently from an earlier state without letter except the artist's name, was in the Haviland sale at the Galerie Georges Petit, June 2nd and 3rd, 1932.

The pose of the stag relates most closely to that of the bronze *Stag Walking* (Pivar A 105), although the legs are here reversed. Also, the bronze stag seems older and larger than that represented in the lithograph, an observation born out by the twelve, as opposed to ten, point antlers of the bronze stag.

In this lithograph, the stag is seen in a kind of isolation; Barye has made little effort to unify the figure with the surrounding landscape. Compared to the *Etude de tigre*, there is less concern here for modulations of tone and atmosphere and more concern for the precise representation of the animal. This treatment seems related to two other lithographs by Barye: the *Ours de Mississipi* (Delteil 6) and the *Jeune axis* (Delteil 7). Contrary to these two lithographs, however, the landscape of *Le Cerf dix cors* is represented fully and with great care. *Le Cerf dix cors* is dated several years later than any other dated print by Barye.

LE CERF DIX CORS.

2

Selected Bibliography

Books

Alexandre, 1889	Alexandre, Arsène. *Antoine-Louis Barye*. Paris: Libraire de l'art, 1889.
Ballu, 1890	Ballu, Roger. *L'Oeuvre de Barye*. Paris: Maison Quantin, 1890.
Benge, 1969	Benge, Glenn F. *The Sculptures of Antoine-Louis Barye in the American Collections, with a Catalogue Raisonné*. 2 vols. Unpublished Ph.D dissertation, University of Iowa, Iowa City, 1969.
Blanc, 1876	Blanc, Charles. *Les Artistes de mon temps*. Paris: Fermin-Didot and Co., 1876.
Claretie, 1882	Claretie, Jules. *Peintres et sculpteurs contemporains*. 1er serie, 6e livraison. Paris: Libraire des bibliophiles, 1882.
De Kay, 1889	De Kay, Charles. *Barye, Life and Works*. New York: The Barye Monument Association, 1889.
Delaborde, 1894	Delaborde, Henri and J. J. Guillaume. *Discours prononcés à l'inauguration du monument élevé à la memoire de Barye, à Paris sur le terre—plein du pont de Sully, le lundi 18 Juin, 1894*. Paris, 1894.
Lengyel, 1963	Lengyel, Alfonz. *Life and Art of Antoine-Louis Barye*. Dubuque, Iowa: Brown, 1963.
Luc-Benoist, 1928	Luc-Benoist. *La Sculpture romantique*. Paris: Renaissance du livre, 1928.
Masters In Art, 1904	Blashfield, E. H. and E. W. and A. A. Hopkins, eds. "Antoine-Louis Barye." In *Masters In Art. A Series of Illustrated Monographs*. vol. 5. Boston: Bates and Guild Company, 1904.
Mackay, 1973	Mackay, James. *The Animaliers: The Animal Sculptors of the 19th & 20th Centuries*. London: Ward Lock Limited, 1973.
Metropolitan, 1940	Remington, Preston. "Barye Sculptures." In *The Metropolitan Museum of Art: A Picture Book*. New York: The Museum Press, 1940.
Muybridge, 1957	Muybridge, Eadweard. *Animals In Motion*. New York: Dover Publications, Inc., 1957.
Pivar, 1974	Pivar, Stuart. *The Barye Bronzes: A Catalogue Raisonné*. Woodbridge, Suffolk: Baron Publishing Co., 1974.
Rosenthal, 1928	Rosenthal, Léon. *L'art et les artistes romantiques*. Paris: Le Groupy, 1928.
Saunier, 1925	Saunier, Charles. *Barye*. Paris: F. Rieder and Co., 1925.
Smith, 1902	Smith, Charles Sprague. *Barbizon Days: Millet, Corot, Rousseau, Barye*. New York: A. Wessels Co., 1902.
Walters, 1885	Walters, W. T., ed. *Antoine-Louis Barye: From the French of Various Critics*. Baltimore: Press of Isaac Friedenwald, 1885.
Zieseniss, 1956	Zieseniss, Charles Otto. *Les Aquarelles de Barye, Étude critique et catalogue raisonné*. Paris: C. Massin, 1956.

Catalogues

Baltimore, 1911	Maryland Institute. *Exhibition of Paintings, Bronzes and Porcelains from the George A. Lucas Collection*. Baltimore, 1911.

Baltimore, 1965

Baltimore Museum of Art. *The George A. Lucas Collection of the Maryland Institute*. Exhibition October 12 – November 21, 1965. Baltimore: Baltimore Museum of Art, 1965.

Barbedienne, 1893

Barbedienne, F. *Bronzes de A. L. Barye*. Boulevard Poissonier, no. 30, Paris, 1893.

London, 1972

The Sladmore Gallery. *Exhibition of Sculpture Antoine-Louis Barye 1796–1875*. June 14 – July 8, 1972. Introduction by Glenn F. Benge. London, 1972.

Los Angeles, 1980

Los Angeles County Museum. *The Romantics to Rodin. French Nineteenth-Century Sculpture from North American Collections*. Los Angeles, 1980.

New York, 1889

American Art Galleries. *Catalogue of the Works of Antoine-Louis Barye*. Barye Monument Association, New York, 1889.

New York, 1971

Parke-Bernet Galleries, Inc. *Bronzes by Antoine-Louis Barye: The Bernard Black – Hugues Nadeau Collection*. December 3, 1971. New York, 1971.

New York, 1973

Shepherd Gallery. *Western European Bronzes of the Nineteenth-Century: A Survey*. New York, 1973.

New York, 1975

Sotheby Parke Bernet. *Barye Bronzes from the Collection of Geraldine Rockefeller Dodge*. October 29, 1975. New York, 1975.

New York, 1982

Christie's East. *Victorian Sculpture*. March 16, 1982. New York, 1982.

Paris, 1876

Hôtel Drouot. *Catalogue des oeuvres de feu Barye. Bronzes, Aquarelles-Tableaux. Cires, terres cuites, marbres, plâtres*. February 7–12, 1876. Paris, 1876.

Paris, 1884

Hôtel Drouot. *Catalogue des bronzes de Barye (modèles)*. April 24, 1884. Paris, 1884.

Paris, 1886

Hôtel Drouot. *Catalogue de bronzes de Barye. Modèles, tableaux et dessins. Composant la collection de M. Auguste Sichel*. February 27, 1886. Preface, "Un Mot," by Edmond de Goncourt. Paris, 1886.

Paris, 1889

Catalogue des Oeuvres de Barye. École des Beaux-Arts. Paris, 1889.

Paris, 1891

Galerie Georges Petit. *Catalogue des bronzes de Barye. Tableaux modernes par Corot, J. Dupré, Géricault et Troyen. Eaux fontes de Rembrandt. Composant la collection de M.CH.B*. January 31, 1891. Paris, 1891.

Paris, 1914

Galerie Georges Petit. *Collection Antony Roux*. May 19–20, 1914. Paris, 1914.

Paris, 1922

Musée national du Louvre. *Catalogue des Sculptures du Moyen Âge, de la Renaissance et des Temps modernes. Deuxieme partie: Temps modernes*. Paris, 1922.

Paris, 1932

Galerie Georges Petit. *Collection George Haviland*. June 2–3, 1932. Paris, 1932.

Paris, 1956–1957

Musée national du Louvre. *Barye: Sculptures, peintures, aquarelles des collections publique francaises*. October 1956 – February 1957. Written by Gerard Hubert, Maurice Serullaz, Jacqueline Bouchot-Saupique. Paris, 1956.

Paris, March 1972

Palais Galliera. *Tableaux modernes: collection de bronzes par Barye, appartenant à divers amateurs*. March 16, 1972. Paris, 1972.

Paris, June 1972

Palais Galliera. *Importante collection de bronzes par Antoine-Louis Barye, appartenant à Madame L . . .* June 9, 1972. Paris, 1972.

Paris, March 13, 1973	Palais Galliera. *Bronzes de Barye*. March 13, 1973. Paris, 1973.
Paris, March 19, 1973	Palais Galliera. *Bronzes par Barye*. March 19, 1973. Paris, 1973.
Quai des Célestins, 10, 1855	*Catalogue des bronzes de Barye, Statuaire, Exposition Universelle, 1855, La Grande Médaille d'Honneur*. Quai des Célestins, 10, Paris, 1855.
Quai des Célestins, 4, 1865	*Catalogue des bronzes de A.-L. Barye, Statuaire, Exposition Universelle, 1865, La Grand Médaille d'Honneur*. Quai des Célestins, 4, Paris, 1865.
12, Rue Chaptal, n.d.	*Catalogue des bronzes de Barye*. 12, Rue Chaptal (Chaussée d'Antin), Paris, n.d.
Rue de Boulogne, No. 6, 1847–1848	*Catalogue des bronzes de Barye*. Rue de Boulogne, No. 6 (Chaussée d'Antin), Paris, 1847–1848.
Rue des Fossés-Saint-Victor, 13, 1855	*Catalogue des bronzes de Barye, Statuaire, Exposition Universelle de 1855, Médaille d'Honneur*. Rue des Fossés-Saint-Victor, 13, Paris, 1855.
Rue Saint-Anastase, 10, n.d.	*Bronzes de Barye en vente dans ses magasins*. Rue Saint-Anastase, Paris (Marais), n.d.
San Antonio, 1965	Marion Koogler McNay Art Institute. *Antoine-Louis Barye 1796–1875*. February 1965. San Antonio, 1965.
Washington, 1939	Corcoran Gallery of Art. *Illustrated Handbook of Paintings, Sculpture and other Art Objects*. Washington, D.C., 1939.
Wasserman, 1975	Wasserman, Jeanne L., ed. *Metamorphoses in Nineteenth-Century Sculpture*. Cambridge: Fogg Art Museum, 1975.
Zoubaloff, n.d.	*La Donation Jacques Zoubaloff aux musées de France*. Preface by Guillaume Janneau. Paris: Editions Albert Moroncé, n.d.

Articles

Aubert, 1947	Aubert, Marcel. "Récentes acquisitions du Départments des Sculptures du Moyen-Âge, de la Renaissance et des Temps Modernes." *Bulletin des Musées de France*, XII (1947): 11–13.
Barry, 1975	Barry, Roxana. "Rousseau, Buffalo Bill and the European Image of the American Indian." *Art News*, 74 (1975): 59–60.
Bazin, 1957	Bazin, Germain. "Département des Peintures." *La Revue des Arts*, VII (1957): 33–34.
Beaulieu, 1975	Beaulieu, Michèle. "Deux bronzes romantiques d'inspiration classique." *Revue du Louvre et des Musées de France*, 25/4 (1975): 269–274.
Benge, 1968–1969	Benge, Glenn F. "Barye's Uses of some Géricault Drawings." *Walters Art Gallery Journal*, XXXI, XXXII (1968–1969, 1971): 13–27, and notes.
Benge, 1974	Benge, Glenn F. "Lion Crushing a Serpent." In *Sculpture of a City: Philadelphia's Treasures in Bronze and Stone*, edited by Nicholas B. Wainwright, pp. 30–35. Walker Publishing Co., 1974.
Crombie, 1962	Crombie, Theodore. "French Animal Bronzes of the Nineteenth Century." *The Connoisseur*, CLI (1962): 245–247.
Eckford, 1886	Eckford, Henry. "Antoine-Louis Barye." *The Century Magazine*, XXXI (1886): 483–500.
Guillaume, 1889	Guillaume, J. J. "Exposition des Oeuvres de Barye a L'École des Beaux-Arts." *Nouvelles Archives de L'Art Français*, 3rd series, vol. 5 (1889): 178–181.

Hamilton, 1936	Hamilton, George Heard. "The Origin of Barye's Tiger Hunt." *Art Bulletin*, XVIII (1936): 249–257.
Henriet, 1870	Henriet, C. d'. "Barye et son Oeuvre." *Revue des Deux Mondes*, 85 (1870): 750–778.
Hubert, 1956	Hubert, Gerard. "Barye et la critique de son temps." *Revue des Arts*, VI (1956): 223–230.
Hubert, 1957	Hubert, Gerard. "Barye . . . ce méconnu." *Jardin des Arts*, no. 27 (1957): 153–158.
Johnson, 1964	Johnson, Lee. "Delacroix, Barye and the Tower Menagerie, an English Influence on French Romantic Animal Pictures." *Burlington Magazine*, CVI (1964): 416–417.
Johnston, 1974	Johnston, William R. "The Barye Collection." *Apollo*, 100 (1974): 402–409.
Mantz, 1867	Mantz, Paul. "Artistes contemporains, M. Barye." *Gazette des Beaux-Arts*, 2eme serie, 1 (1867): 107–126.
Millard, 1975–1976	Millard, Charles W. "Sculpture and Theory in Nineteenth-Century France." *Journal of Aesthetics and Art Criticism*, 34/1 (1975–1976): 15–20.
Peignot, 1972	Peignot, Jerome. "Barye et les bêtes." *Connaisance des Arts*, no. 243 (1972): 116–121.
Planche, 1851	Planche, Gustave. "Barye." *Revue des Deux Mondes*, XI (1851): 47–75.
Raynor, 1963	Raynor, V. "Barye Exhibition at Alan Gallery." *Arts* XXXVIII (1963): 64.
Roger-Marx, 1930	Roger-Marx, Claude. "Barye, Peintre et Aquarelliste." *L'Art Vivant*, VI, no. 137 (1930): 687–690.
Rogers, 1970	Rogers, Ann W. "An Introduction to Three Sketchbooks from the Institute's Collection." *The Minneapolis Institute of Arts Bulletin*, LIX (1970): 58–67.